IMAGES
of America

BOSTON BRAVES

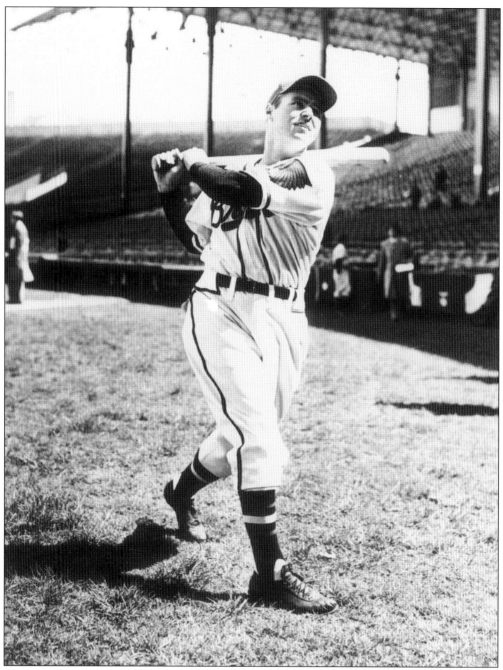

TOMMY HOLMES, C. 1947. Casey Stengel called Braves right fielder Tommy Holmes the best leadoff batter he ever managed. The former Yankee farmhand arrived in Boston in 1942 and soon became a fan favorite. In 1945, he set a National League record by hitting in 37 consecutive games and led the league with 28 home runs. (J. Brooks.)

IMAGES
of America

BOSTON BRAVES

Richard A. Johnson

ARCADIA

Published by Arcadia Publishing
Charleston SC, Chicago IL, Portsmouth NH, San Francisco CA

Printed in Great Britain

Library of Congress Catalog Card Number: 2001086984

For all general information contact Arcadia Publishing at:
Telephone 843-853-2070
Fax 843-853-0044
E-mail sales@arcadiapublishing.com
For customer service and orders:
Toll-Free 1-888-313-2665

Visit us on the internet at http://www.arcadiapublishing.com

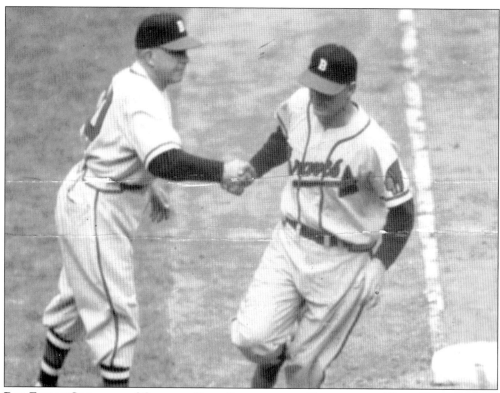

BOB ELLIOT GREETED BY MANAGER BILLY SOUTHWORTH FOLLOWING A HOME RUN, C. 1947.
Like many managers of his era, Billy Southworth managed his team from both the dugout and
the third base coach's box. Here Southworth greets Bob "Mr. Team" Elliot on one of the 22
home run trots he took during his MVP season in 1947. (G. Sullivan.)

CONTENTS

ACKNOWLEDGMENTS

I first became aware of the Boston Braves in grade school, when the names Spahn and Sain entered my sports vocabulary. The team, which departed the region a decade earlier, was by then nearly forgotten and existed only in a world of black-and-white photographs and the animated conversations of old men. When I was hired a curator of the Sports Museum of New England (SMNE) in 1982, the Braves were the focus of the first major research project I undertook. It was then that the tales of this storied franchise came to life as I learned of 10 National League pennants, a miracle World Series, a legion of colorful players and executives and a cadre of fans as loyal as any in sports.

I am especially grateful to three men without whose assistance this book would have been an impossibility. John Brooks, George Altison, and George Sullivan could not have been more supportive in sharing their wealth of Braves photographs and their incredible enthusiasm and expertise. Altison is the head of the Boston Braves Historical Society, which publishes a richly informative newsletter as well as many speciality publications. The society's annual October banquet is an unparalleled gathering of former players and fans.

I am also grateful to my colleagues at the Sports Museum of New England for their support. Included on the museum team are the following: Bill Galatis, Brian Codagnone, Michele Gormley, Tina Anderson, Len Andexler, Gordon Katz, Gene Valentine, Jan Volk, Rich Krezwick, Jim Bednarek, John Wetzel, Laurie Voke, Peter Webber, Jim Delaney, Jim Davis, Tom Yewcic, Dave Cowens, Vic Caliri, Dick Malatesta, Steve Karp, Paul Dietrich, Dr. Michael Foley, Richard Gold, Robert Margil, Richard Pond, Hon. Mal Graham, Bill Littlefield, Soosie Lazenby, Steve Belkin, Len Bernheimer, Jim Dragon, John Tighe, Armand LaMontagne, Tony Lawrence, Sherwin Kapstein, and Jon Bonsall.

The work of writers and historians such as Gary Caruso, Bob Walsh, Frederick Lewis, Mabere "Doc" Kountze, Bob Brady, Wayne Soini, Glenn Stout, Saul Wisnia, and Harold Kaese provided both insight and inspiration.

I also deeply appreciate the assistance of Dennis Brearley, Michael Andersen, Charles Caliri, Kevin Aylward, Bob Walsh, Fred Surabian, Charles O' Rourke, Tom Stack, Dr. Joseph Desmond, Jerry Nason, John Cronin, Mark Torpey, Don Skwar, Michele L. Amundsen, Pat Kelley, the Boston Public Library (BPL), and the National Baseball Hall of Fame (NBHOF). Special thanks are extended to Amy Sutton and the staff of Arcadia Publishing.

This book is dedicated with love to my home team of Boston Braves, namely Mary, Bobby, and Lizzie—sluggers all.

—Richard A. Johnson

INTRODUCTION

Long before media mogul Ted Turner made the Boston Braves America's team, they belonged exclusively to Boston. For 76 years, National League Baseball was central to the New England sports scene, as the Braves captured 10 pennants and a world championship before moving to Milwaukee in 1953. In Boston, they played in the elegant confines of the South End Grounds, the tiny harborside Congress Street Grounds, and as temporary tenants at Fenway Park before opening Braves Field, the largest ballpark in America at the time, in 1915.

At the time of their move to Milwaukee in 1953, the Braves had seen their home attendance drop from an all-time high of 1,455,439 in 1948 to an embarrassing total 281,278 in 1952. For the entire 1952 season, the club attracted only two single-game crowds of 10,000 or more as 76 years of National League baseball in Boston receded into obscurity. As the team died in Boston, the franchise was slowly being reborn, in the Minor League system, featuring a teenage slugger named Henry Aaron. Not only did Boston miss the record-setting talent of Aaron but also two more pennants and a World Series triumph over the Yankees in 1957. For older fans in Boston, it sparked memories of past glories.

The heyday of the franchise was the 1890s, when the team, then known as the Beaneaters, established itself as a bona fide dynasty while capturing five pennants in eight seasons. Following the turn of the century, their amazing and improbable triumph as the "Miracle Braves" was forged in 1914 as they surmounted a $10^1/2$-game, last-place deficit on July 4 to win the pennant by an identical margin over the New York Giants. They capped the season with the first ever World Series four-game sweep (of the Athletics). Their victory was subsequently named by the Associated Press as the greatest sports upset of the first half of the 20th century.

Among the 38 Braves to represent the team at the National Baseball Hall of Fame are players as talented and colorful as Kid Nichols, Warren Spahn, Johnny Evers, King Kelly, "Rabbit" Maranville, Hugh Duffy, George Wright, Harry Wright, Eddie Matthews, and Vic Willis. Of the six uniform numbers retired by the Atlanta Braves, two were worn by their Boston brothers: Warren Spahn (No. 21) and Eddie Matthews (No. 41). Hank Aaron (No. 44) was under contract to the Boston organization before embarking on a legendary career in Milwaukee and Atlanta.

The Boston legacy is still manifest on the Atlanta Braves home uniforms, which are very nearly identical in design to that of the flannels last worn by their Boston ancestors at spring training in 1953. The Boston heritage is also celebrated by the Atlanta Braves in their museum at Ted Turner Field, where they now play.

In Boston, the most permanent legacy of the team is the world-renowned Jimmy Fund of the Dana Farber Cancer Institute. Founded in 1947 by Boston Braves president Louis Perini Jr.

and team publicist Billy Sullivan, the Jimmy Fund has raised tens of millions of dollars and has contributed to countless lifesaving developments in the fields of cancer research and treatment. Since the Braves' departure from Boston in 1953, the Jimmy Fund has been supported in large part by the Boston Red Sox and Yawkey Family Trust as well as the continued involvement of the Perini family.

For over three quarters of a century, the Braves performed as one of the two longest continually operated teams in Major League baseball while making Boston their home. Both on and off the field, the franchise will forever be remembered as Boston's working-class heroes. Following the birth of the American League in 1901, they struggled as the poor relations of their Back Bay baseball neighbors, the Red Sox. While shouldering their burden as underdogs, they persistently pursued new fans by introducing such schemes as both Sunday and night baseball, satin uniforms (for the enhancement of television viewing), comprehensive radio and television coverage, baseball's first color highlight films, Fan Appreciation Days, and the beloved Knothole Gang.

In April 1950, outfielder Sam Jethroe made history as Boston's first African American Major Leaguer. He would soon be followed by a gangly rookie slugger named Henry Aaron, who represented the Boston organization in the Minor Leagues in Eau Claire, Wisconsin, at the time of the team's relocation. One can only imagine the fortunes of the Spahn-Matthews-Aaron-Adcock-era Braves in Boston at a time when the Red Sox were mediocre at best. Many stubborn fans insist to this day that the wrong team departed Boston on Friday March 13, 1953.

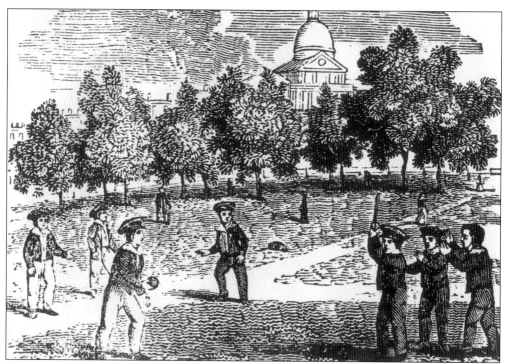

BASEBALL ON BOSTON COMMON, C. 1834. Early baseball in New England was known as either "the Boston game" or "town ball" and can be traced to the game of rounders in England. This illustration from a children's book is the earliest-known picture of a baseball game in the United States. (SMNE.)

One

A DYNASTY ACHIEVED AND DENIED, 1876–1890

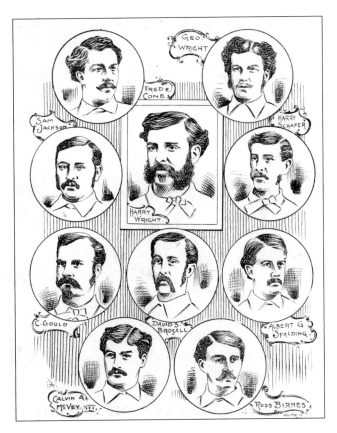

BOSTON RED STOCKINGS, NATIONAL ASSOCIATION CHAMPIONS, C. 1871. In the five-year history of the National Association, the Boston Red Stockings won four league championships. They were led by slugging second baseman Ross Barnes and pitcher A.G. Spalding. Over five seasons, Spalding won an astounding 205 games and averaged over 500 innings pitched per season. (Author's collection.)

GEORGE WRIGHT, C. 1871. George Wright was one of the great players in early professional baseball. The son of an English cricket star, Wright virtually invented the position of shortstop. He led both the Cincinnati and Boston Red Stockings to unparalleled success before helping to lead Boston's entry into the newly formed National League in 1876. He later went on to play for a team in Providence. (Author's collection.)

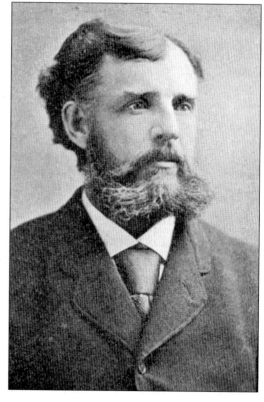

HARRY WRIGHT, C. 1871. Originally a cricket star like his father, Harry Wright played center field for the legendary Boston Red Stockings. In 1876, he was named the first manager of Boston's entry into the fledgling National League. In 1877 and 1878, Wright led his team to consecutive pennants. His streak was broken in 1879 by the Providence team led by his younger brother and former teammate George Wright. (Author's collection.)

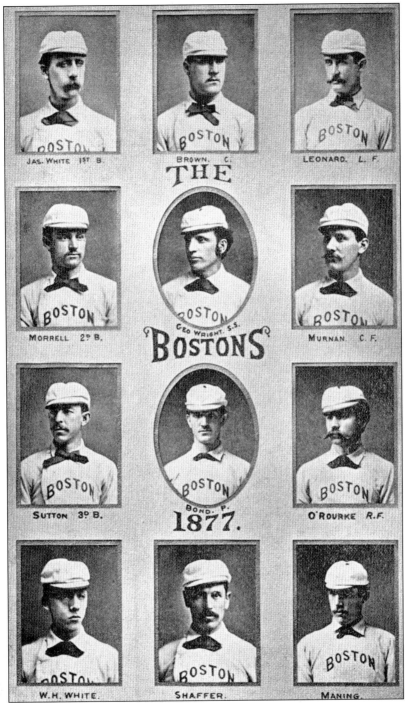

THE 1877 CHAMPION BOSTON NATIONALS. The 1877 Boston Nationals were the first of Boston's ten National League pennant winners. Led by pitcher Tommy Bond, with 40 victories in 58 games (of the team's 60-game season), and first baseman Deacon White, who led the league in batting average with .387 and RBIs with 49, the Boston Nationals (or simply the Bostons) won 42 games and lost only 18. (Author's collection.)

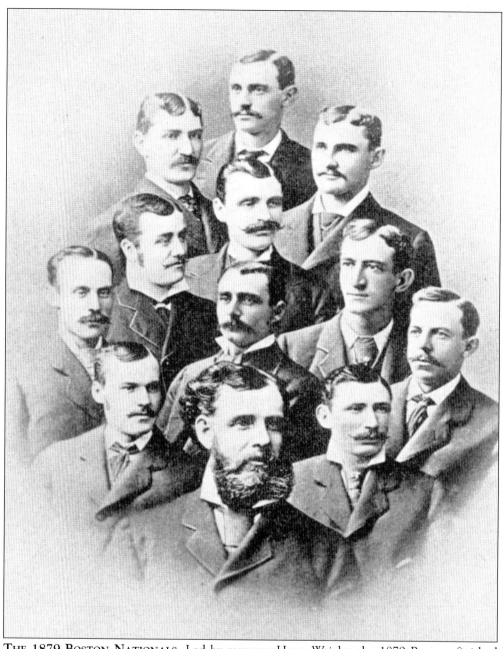

THE 1879 BOSTON NATIONALS. Led by manager Harry Wright, the 1879 Bostons finished five games behind the Providence Grays, managed by Harry's brother George. Despite Tommy Bond's 43 victories, the Bostons could not match the 47-win season of the Grays, led by Monte Ward. Note that only one of the Boston team members lacks facial hair in this montage of player portraits.

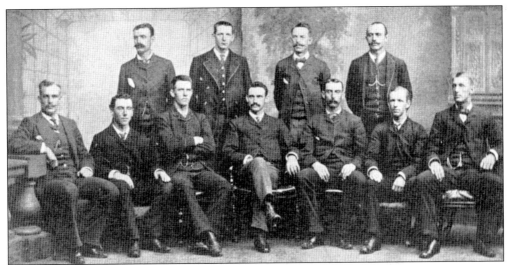

THE 1883 CHAMPION BOSTON NATIONALS. The 1883 team, known as "the Red Caps," captured the fourth National League crown for Boston in the first eight years of the league. Their star pitcher, "Grasshopper Jim" Whitney, won 37 games in a season that saw him pitch 54 complete games and strike out a league-leading 345 batters. (NBHOF.)

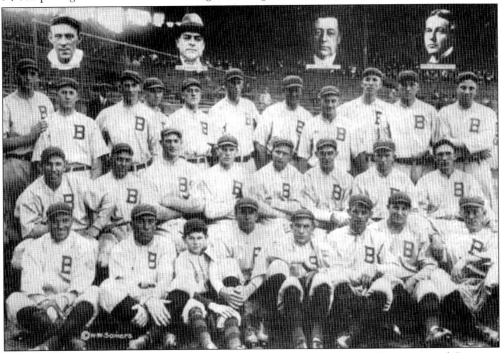

CONGRESS STREET GROUNDS, C. 1894. Located near the Boston waterfront at A and Congress Streets, the Congress Street Grounds served as home to three Major League teams. The Players League Champion Boston Reds played their one and only season in the park in 1890. The American Association team of the same name played there in 1891 and the Boston Nationals played there following the fire that destroyed the South End Grounds from May 16, 1894, to June 20, 1894. The cozy bandbox featured a 250-foot left field porch and was the site of Bobby Lowe's historic four-home run game on May 30, 1894. (Author's collection.)

13

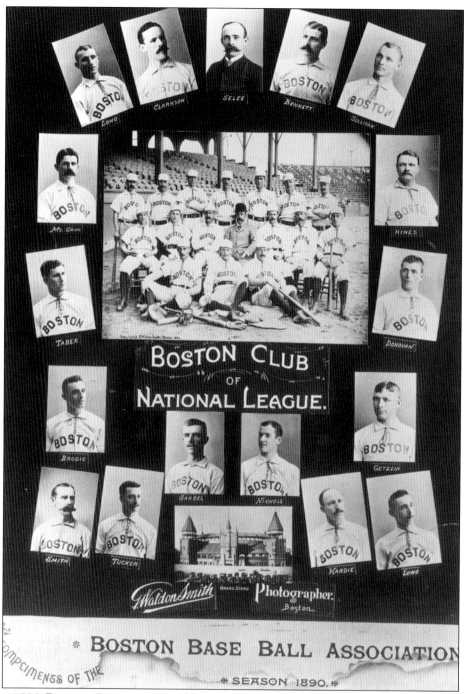

THE 1890 BOSTON BEANEATERS. Although the 1890 Boston Beaneaters finished in fifth place, 12 games behind the Brooklyn Bridegrooms, the team was full of talent and promise. Hall of Fame pitchers Charles "Kid" Nichols and John Clarkson won 27 and 25 games, respectively. Manager Frank Selee was in the first season of an 11-year reign as manager. During his career, he led Boston to five National League titles in a span of eight years. Selee's teams averaged 87 wins in a 135-game season, for a winning percentage of .644. (NBHOF.)

Two

SELEE'S CHAMPIONS, 1890–1900

ADVERTISEMENT FOR OUTFIELDER TOMMY McCARTHY'S BOWLING ALLEY, c. 1897. Boston native Tommy McCarthy was one of the so-called "Heavenly Twins," along with outfield mate Hugh Duffy. McCarthy played five of his 13 Major League seasons with Boston and helped lead the team to back-to-back pennants in 1892 and 1893. For many years, he ran a bowling alley in Boston. In 1946, he was one of the first players enshrined by the Veterans Committee in the National Baseball Hall of Fame. (Author's collection.)

JAMES B. McALOON & CO.

= Merchant Tailors, =

125 TREMONT, OPPOSITE PARK STREET,

BOSTON.

THOMAS F. McCARTHY FORMERLY DUFFY & McCARTHY BOWLING

ALES WINES AND LIQUORS
IMPORTED AND DOMESTIC CIGARS · · · 603 Washington St opp. Hayward Place BOSTON · · ·

HOTEL SAVOY,

Washington Street, Boston.

EUROPEAN PLAN. LADIES' AND GENTLEMEN'S CAFES.

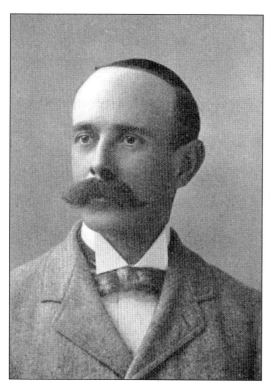

FRANK SELEE, C. 1890. In six years, Frank Selee rose from the rank of player-manager of the Melrose, Massachusetts town team to manager of the Boston Nationals. Along the way, he led a series of pennant winners, starting in Haverhill Massachusetts, before making the journey west to Oshkosh, Wisconsin, and finally to Omaha, Nebraska. In 12 seasons as Boston manager, he led his team to five pennants and dynasty status. A man of fiery ambition but of few words, his simple credo was "If I make things pleasant for the players, they reciprocate." (Author's collection.)

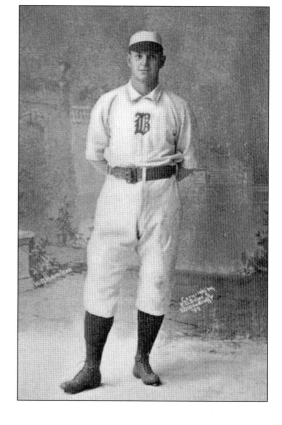

WILLIAM "SLIDING BILLY" HAMILTON, C. 1897. Not only was Billy Hamilton the premier base runner of his era, but the diminutive outfielder was also a superb hitter who boasted a .344 career batting average over 14 Major League seasons. In 1897, he helped lead the Boston Nationals to a pennant with his superb play in center field and a .343 batting average.

CHARLES "KID" NICHOLS. Kansas City native Kid Nichols achieved an amazing record in Boston, winning 30 or more games for seven straight seasons from 1891 to 1897. The crafty right-hander finished his career with 362 victories and was elected to the National Baseball Hall of Fame in 1949. (BPL.)

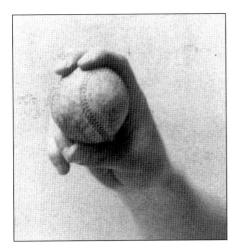

KID NICHOLS'S PITCHING GRIP. Known as one of the great control artists of all time, right-hander Kid Nichols delivered his fastball with a deceiving no-windup delivery. His pinpoint control allowed him to complete all but 30 of his 561 career starts. (BPL.)

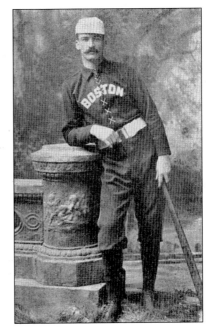

MIKE "KING" KELLY. The man known simply as "King" was the first team sport superstar in America. Like his boxing counterpart John L. Sullivan, Kelly's talent was only matched by his colorful character. His personal habits included more than his fair share of heavy socializing. A multiposition player, Kelly achieved a lifetime average of .307. He also inspired a popular parlor song of the day entitled "Slide Kelly, Slide." At his deathbed at the tender age of 36, he was purported to have told a teammate, "I'm sliding home." Ultimately, he was a victim of his own excessive exuberant lifestyle. (NBHOF.)

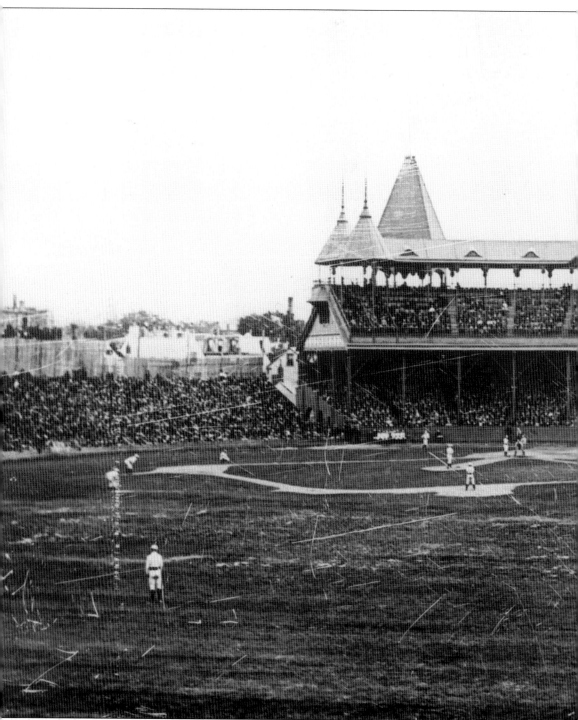

THE SOUTH END GROUNDS, C. 1890. The original version of the South End Grounds was the most elegant Major League ballpark in the 19th century. The park was also Boston's first, and to date its only, true double-decked outdoor stadium. The park, which burned in the South End fire of 1894, was rebuilt as but a shadow of its former self, since its insurance settlement

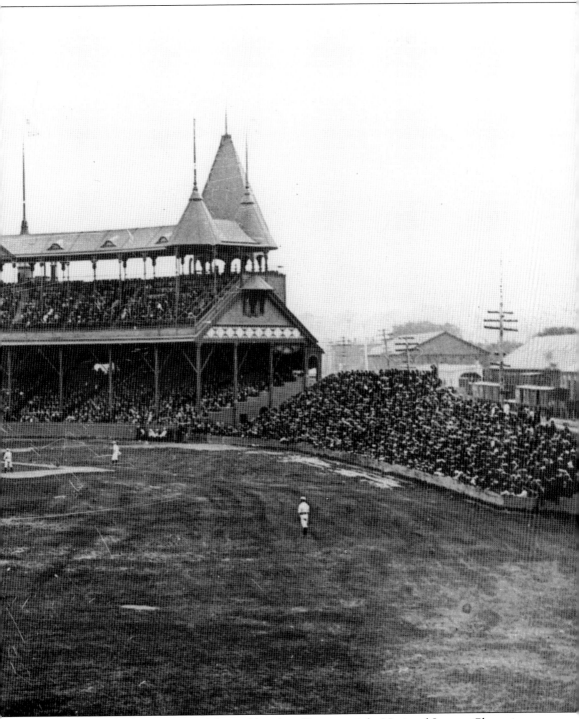

that equaled only 60 percent of the park's value. Home to eight National League Champions, the South End Grounds was located on what is now the Ruggles MBTA rail station adjacent to Northeastern University. (Bostonian Society.)

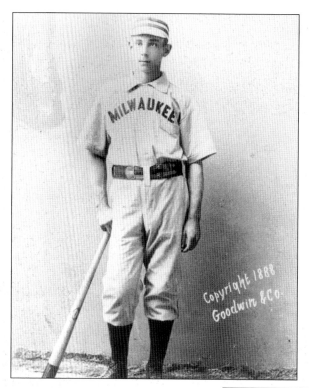

ROBERT LINCOLN "BOBBY" LOWE, C. 1897. Standing five feet, ten inches tall and weighing 150 pounds, Bobby Lowe was hardly the prototype slugger. On May 30, 1894, however, the Boston Beaneaters' second baseman made baseball history when he socked four home runs in the second game of a morning-afternoon doubleheader at the cozy Congress Street Grounds on Boston's waterfront. Not only was Lowe the first to achieve this feat, but his assault on the Cincinnati Reds came in consecutive at-bats. Following his fourth homer, fans showered him with over $100 in coins and dollar bills in appreciation of his feat. His fifth and final at-bat produced a single. (Author's collection.)

HUGH DUFFY. Rhode Island native Hugh Duffy was one of the Beaneaters' "Heavenly Twins," along with fellow future Hall of Fame outfielder Tommy McCarthy. In 1894, Duffy won the National League Triple Crown with a record-setting .438 batting average, 18 home runs, and 145 RBIs. Duffy served as both a hitting instructor and roving goodwill ambassador for the Red Sox in his later years. (BPL.)

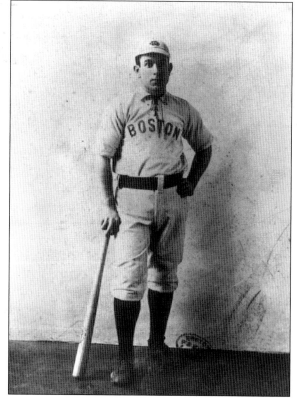

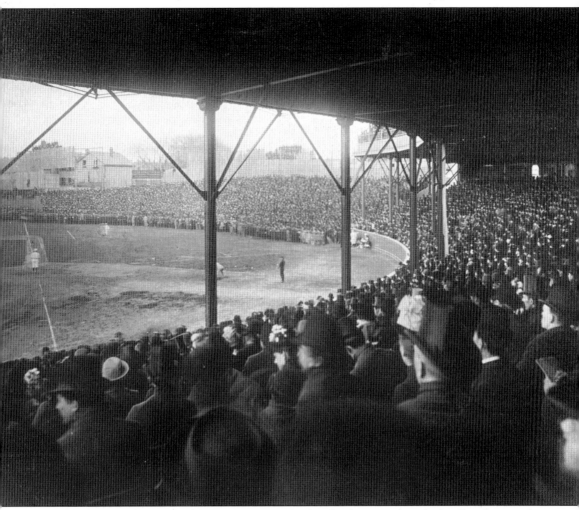

THE SOUTH END GROUNDS, C. 1892. Note the bowler hats on the nearly all-male crowd at this sold-out Beaneaters game. The ballpark, despite its elegant design, was a rowdy place, where alcohol, tobacco, and gambling meshed perfectly with the hardball played by Frank Selee's charges. (NBHOF.)

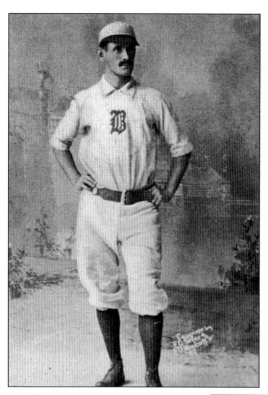

FRED TENNEY. In an era when professional baseball was mostly played by illiterate tradesmen, Brown University graduate Fred Tenney stood out as both a gentleman and an extremely nimble first baseman. Many have pronounced the Georgetown, Massachusetts native the best first baseman (along with Gil Hodges) not enshrined in the Hall of Fame. Tenney batted .294 over a 17-year career and also invented the 3-6-3 double play. (NBHOF.)

JIMMY COLLINS, C. 1899. In six seasons with the Boston Nationals, Jimmy Collins established himself as one of the greatest third basemen ever. Not only did he recast the position defensively by bare-handing bunts, but he was also an outstanding hitter, batting .309 for Boston while averaging nearly 90 RBIs per full season. He helped lead the Nationals to back-to-back pennants in 1897 and 1898. He anchored an infield (considered the best of the 19th century) that included first baseman Tenney, shortstop Herman Long, and second baseman Bobby Lowe. Collins's move to the Boston Americans in 1901 was a major blow to both the team and the entire National League. (G. Altison.)

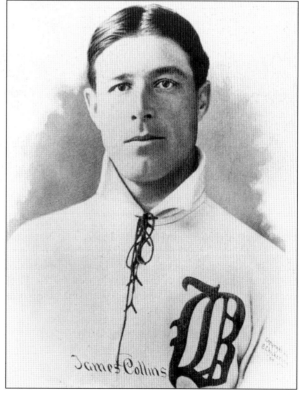

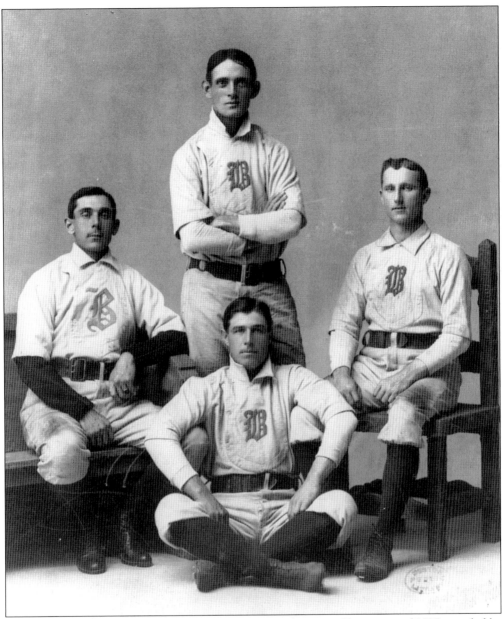

BOSTON BEANEATERS INFIELD, C. 1897. The National League Champions of 1897 were led by these infielders. They are, from left to right, as follows: (sitting) third baseman Jimmy Collins; (standing) second baseman Bobby Lowe, first baseman Fred Tenney, and shortstop Herman Long. Although only Collins is enshrined in the Hall of Fame, Lowe gained immortality by becoming the first Major Leaguer to hit four home runs in a nine-inning game. (BPL.)

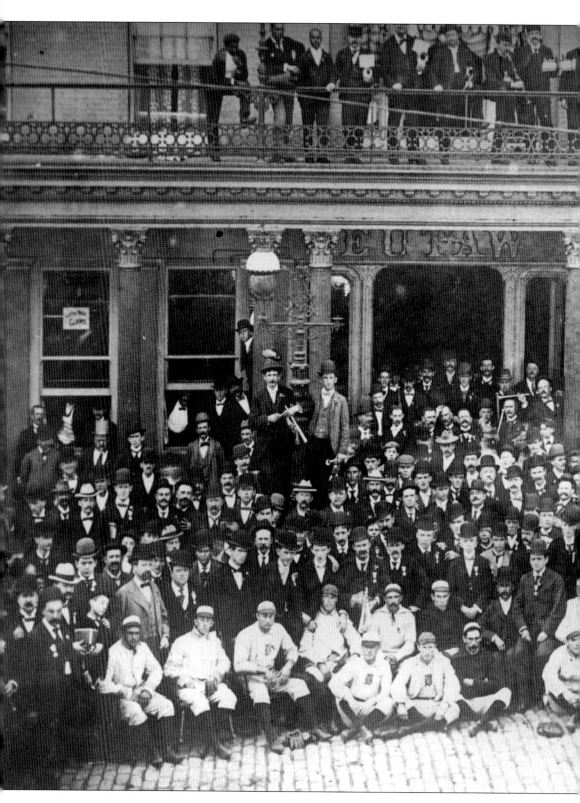

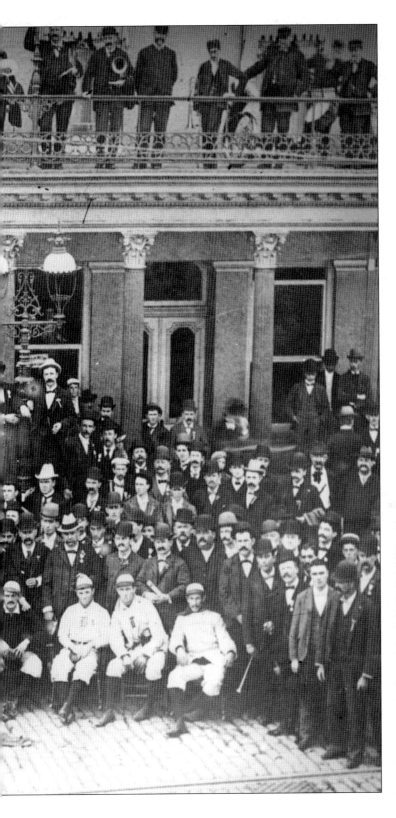

THE ROYAL ROOTERS IN BALTIMORE, C. 1897. Boston's Royal Rooters, led by saloon keeper Michael "Nuf Ced" McGreevey, were a raucous assortment of fans who often traveled to big games with their own marching band. The Rooters are shown in Baltimore for the 1897 Temple Cup series, a precursor of the World Series. Despite winning the regular season pennant, the Beaneaters lost to the Orioles in the Temple Cup by four games to one. (NBHOF.)

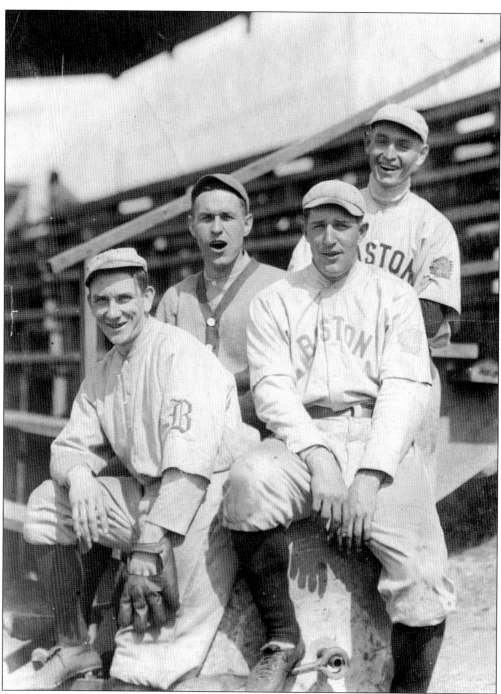

THE BRAVES QUARTET, SPRING TRAINING 1913. Shortstop "Rabbit" Maranville was the life of the party for all of his nearly quarter-century playing career. The 21-year-old star is shown in a playful moment with teammates at spring training in Hot Springs, Arkansas. Following the 1914 World Series victory, Maranville and several teammates performed on the vaudeville circuit. Posing, from left to right, are the following: (front row) Rabbit Maranville and Jay Kirke; (back row) Fred Smith and Bill McTigue. (G. Sullivan.)

Three

HARD TIMES AND A MIRACLE ON WALPOLE STREET, 1900–1914

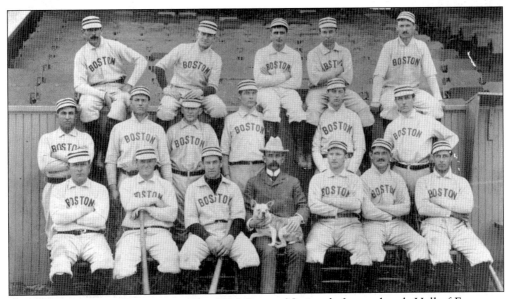

THE 1900 BOSTON NATIONALS. The 1900 Boston Nationals featured such Hall of Famers as manager Frank Selee, third baseman Jimmy Collins, outfielders Hugh Duffy and Billy Hamilton, and pitchers Vic Willis and Kid Nichols. Despite such talent, the team finished below .500 in fourth place and started a downward spiral, broken only a third place finish in 1902. Within a season, the newly formed Boston Americans tore the heart out of the franchise by securing the services of such fan favorites as Jimmy Collins, Buck Freeman, and Chick Stahl. (BPL.)

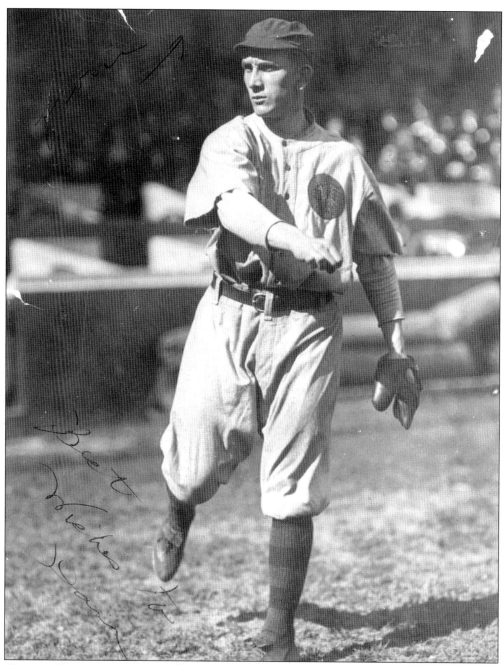

WALTER "RABBIT" MARANVILLE. Walter Maranville was a player beyond the scope of mere statistics. Arriving in Boston as a teenager in 1912, the native of Springfield, Massachusetts, soon became a fan favorite. Among his tricks was a warm-up routine where he would sit on second base and throw perfect strikes to the catcher. He batted .308 in the 1914 World Series. (SMNE.)

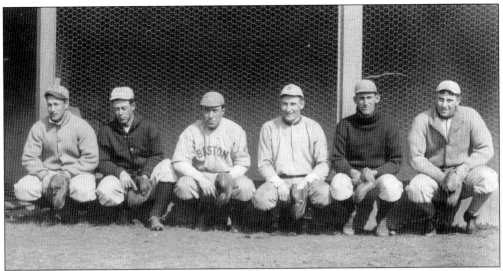

BRAVES CATCHERS AT SPRING TRAINING, C. 1913. Shown from left to right are Braves catchers Rex Dwaft, Bill Rariden, Fred Mitchell, Drummond Brown, ? Gonzalez, and Bert Whaling. Of this group only Rariden, Mitchell, Brown, and Whaling made the big league team. Rariden started 95 games for the fifth-place team. (G. Sullivan.)

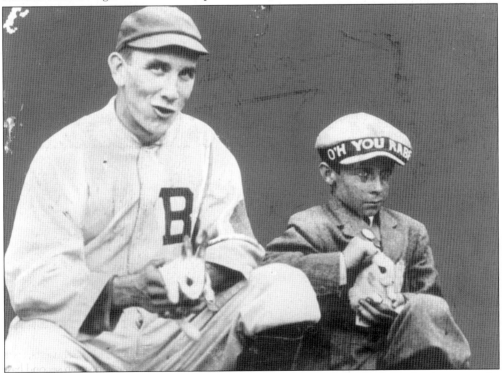

RABBIT MARANVILLE DAY. Twenty-year-old Maranville was given a day in his honor at the South End Grounds in 1913. A multitude of friends and well-wishers from his hometown of Springfield made their way to Boston to celebrate the colorful antics of their hero. He is shown with a suitably attired young fan in a pregame ceremony that included the presentation of young rabbits to the shortstop. (NBHOF.)

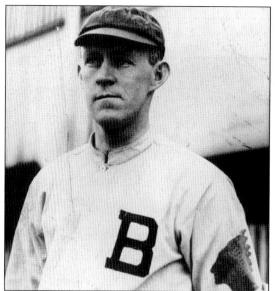

JOHNNY EVERS. Johnny Evers arrived from the Chicago Cubs in late 1913 with a reputation as the most temperamental player in baseball. He soon discovered his alter ego in manager George Stallings, and together they helped lead the Braves to their best season. Evers was rewarded with the Chalmers Award, similar to the Most Valuable Player in the National League, while batting only .279, with one home run and 40 RBIs. (NBHOF.)

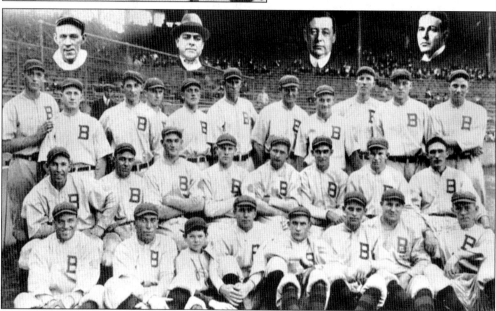

WORLD CHAMPION "MIRACLE BRAVES" OF 1914. The 1914 Miracle Braves were chosen by the Associated Press as having scored the greatest sports upset of the first half of the 20th century. Not only did the team rise from last place on July 4 to whip the heavily favored New York Giants by a comfortable 10½-game margin, but they also became the first team ever to sweep a World Series when they defeated the Philadelphia Athletics in four straight games.

Shown from left to right are the following: (front row) Joe Connolly, Fred Mitchell, Willie Connor, Dick Rudolph, Rabbit Maranville, Dick Crutcher, John Martin, and Johnny Evers; (middle row) George Whitted, Oscar Dugay, George Tyler, Paul Strand, Josh Devore, Larry Gilbert, Red Smith, and Herb Moran; (back row) Bill James, Ted Cather, Charles Deal, George Davis, Ensign Cottrell, Eugene Cochreham, Otto Hess, Leslie Mann, Hank Gowdy, Butch Schmidt, and Bert Whaling. The insets show, from left to right, Johnny Evers (captain), George T. Stallings (manager), James E. Gaffney (owner), and Herman Nickerson (secretary). (SMNE.)

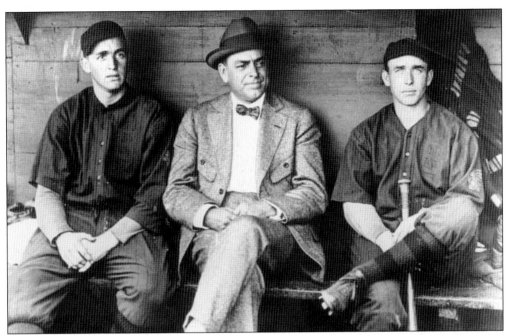

BILL JAMES, GEORGE STALLINGS, AND DICK RUDOLPH, C. 1914. George Stallings led his team with an iron fist and was known to admonish his men with the directive "You can win, you must win, you will win." He was also a pioneer in the art of "platooning" and used this skill to lead his team from last to first in less than two months in the miracle summer of 1914. (NBHOF.)

BRAVES MANAGER GEORGE STALLINGS. Stallings was the son of a Civil War Confederate officer and was one of the most colorful and dynamic managers in baseball history. The intelligent former catcher was also a dropout from Johns Hopkins Medical School and, along with Connie Mack, was one of the only managers to wear street clothes on the bench. Here he is topped by his trademark straw boater hat. (NBHOF.)

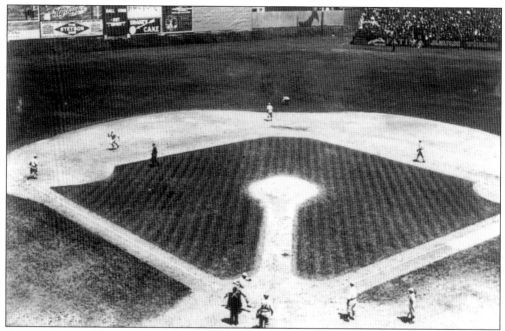

FENWAY PARK. This 1917 photograph shows Fenway Park nearly the same as it looked when the Braves played the final third of the 1914 regular season and the World Series at the famed ball yard. Note the slope of Duffy's Cliff in left field and the patchwork of advertising on the wooden left field wall. (M. Andersen.)

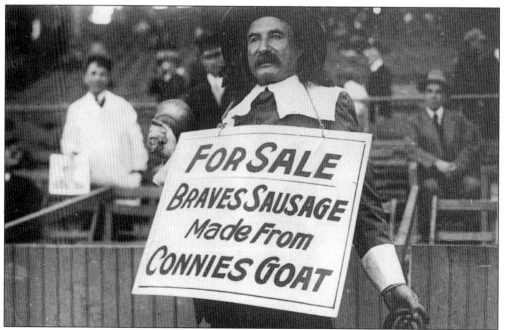

BRAVES FAN AT FENWAY PARK FOR THE 1914 WORLD SERIES. One intrepid fan mocks Athletics manager Connie Mack prior to the fourth and final game of the 1914 World Series played at Fenway Park. He, along with many members of the fabled Royal Rooters, gladly rooted for both the Red Sox and Braves during the glory years of that time. (SMNE, Bradley Donation.)

PITCHER BILL JAMES. Big right-hander Bill James enjoyed the season of his career in 1914, when he won 26 games and lost only seven while leading the league with a winning percentage of .788. In four Major League seasons, James won only 37 games, not including his two victories over the Athletics in the World Series. His World Series earned run average for 11 innings was a perfect 0.00. (NBHOF.)

DICK RUDOLPH. Dick "Baldy" Rudolph won a league-leading 27 games as a member of the 1914 Braves "Big Three" pitching staff, along with Bill James and Lefty Tyler. The 27-year-old right-hander enjoyed the greatest of his 11 years as a member of the Braves. He also won two games in the 1914 World Series with an earned run average of 0.50 in 18 innings. (G. Altison.)

LEFTY TYLER. George "Lefty" Tyler of Derry, New Hampshire, helped lead the Braves to their miracle championship with a won-lost record of 16-13. He also pitched 10 innings without a decision in the Braves victory in game three of the 1914 World Series at Fenway Park. (G. Altison.)

CATCHER BERT WHALING, c. 1914. Backup catcher Bert Whaling batted only .209 in the miracle season of 1914. He spent his entire three-season Major League career as a backup catcher, platooning with Hank Gowdy from 1913 to 1915. He led the National League in fielding percentage (.990) in 1913 and batted for a lifetime average of .225. (G. Altison.)

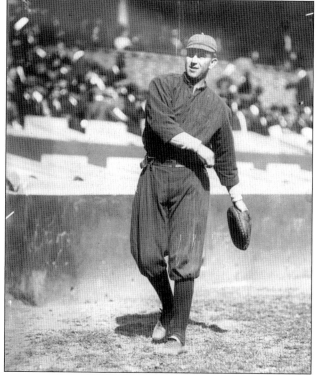

CENTER FIELDER LESLIE MANN, c. 1914. George Stallings "platooned" Les Mann in center for much of the 1914 season; the slick-fielding center fielder batted .247 in 126 games for the miracle men. Mann saw limited duty in that World Series, batting a solid .286 in three games. (G. Altison.)

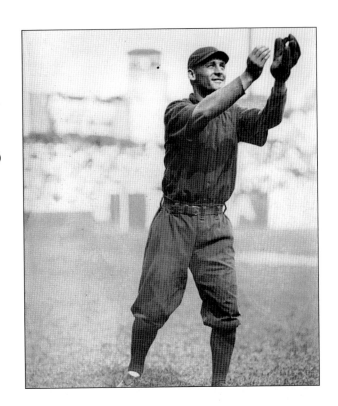

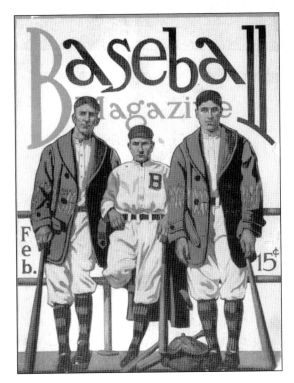

BASEBALL MAGAZINE, FEBRUARY 1915. This issue was devoted entirely to the unprecedented success of the recently crowned World Champion Boston Braves. Inside were extensive articles on manager George Stallings, MVP Johnny Evers, and the saga of the 1914 World Series. (Author's collection.)

Miracle Braves Reunion Celebration, c. 1951. Among the members of the 1914 Miracle Braves to gather at a banquet at the Somerset Hotel are, from left to right, Fred Mitchell of Boston; Dick Crutcher of Frankfort, Kentucky; George "Lefty" Tyler of Lowell; Hank Gowdy of Columbus, Ohio; Bill James of Oroville, California; Paul Strand of Salt Lake City, Utah; and J. Carlisle "Red" Smith of Atlanta, Georgia.

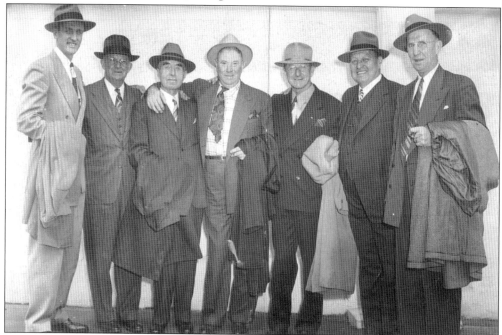

Miracle Braves Gather at Braves Field, October 6, 1948. The Braves invited members of the Miracle Braves back to watch the 1948 World Series at Braves Field. Shown from left to right are some of the invitees: George Stallings Jr. (son of manager George Stallings), Red Smith, Fred Mitchell, Bert Whaling, Chuck Deal, Butch Schmidt, and Hank Gowdy.

Four

THE PALACE OF BASEBALL, BRAVES FIELD, 1915–1923

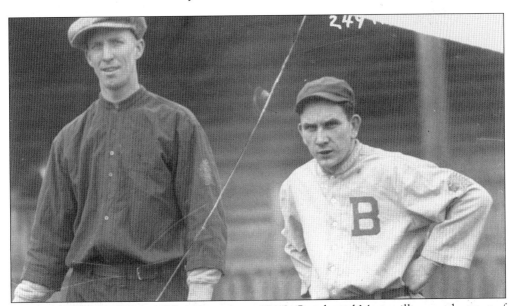

HANK GOWDY AND RABBIT MARANVILLE, C. 1915. Gowdy and Maranville were the toast of Boston and all of baseball following the Braves' improbable triumph in the 1914 World Series. Not only did Gowdy bat .545 to lead all hitters in the series, but he also socked the Braves (and series) only home run to help win game three at Fenway Park. Maranville batted .308 while playing his usual, spectacularly flashy defense. In 1915, both played at the opening game of Braves Field, baseball's largest ballpark. (G. Altison.)

The Boston National League Club

requests the honor of your presence

at the opening game in

Braves Field

Commonwealth Avenue, Allston

on Wednesday, August the eighteenth

nineteen hundred and fifteen

and at the raising of the

World's Championship Baseball Pennant

immediately preceding the game

Boston vs. St. Louis

Three-fifteen o'clock

Card enclosed should be

presented at the press gate

INVITATION TO THE GRAND OPENING OF BRAVES FIELD, AUGUST 18, 1915. After winning the 1914 World Series, the Braves decided to follow the lead of their Back Bay rivals and build a new ballpark. They hired the same firm that had designed Fenway Park, Osborn Engineering Company of Cleveland, Ohio, and constructed their park on the site of the Allston Country Club. A section of the original grandstand survives; it is now the main stand at Boston University's Nickerson Field. (SMNE.)

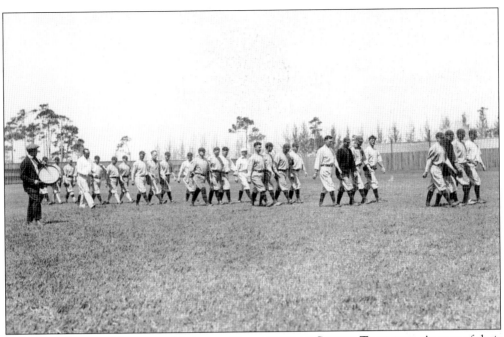

THE 1917 BRAVES MARCH IN MILITARY FORMATION AT SPRING TRAINING. As part of their spring training regimen, the 1917 Braves were required to march in military formation for this World War I–era photo opportunity. At the time this photograph was taken, many Americans felt that Major League baseball should be suspended until the end of the war. Note the drummer at the left (above). Before the end of the season, catcher Hank Gowdy became the first Major Leaguer to enlist for service in the war. (G. Sullivan.)

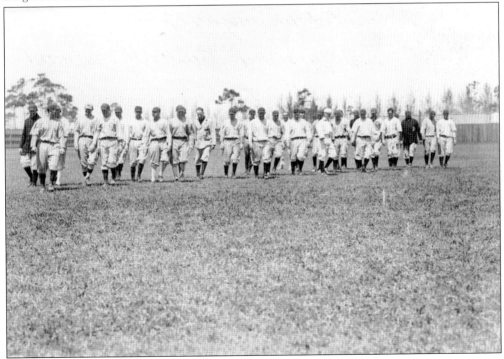

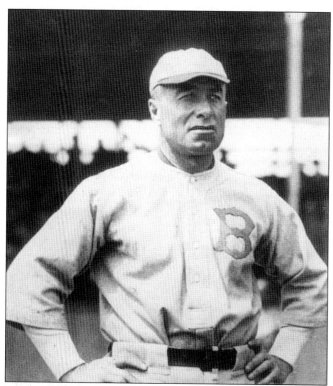

BRAVES MANAGER FRED MITCHELL, C. 1923. In 1914, Fred Mitchell served as George Stallings's first-base coach. He later managed the Chicago Cubs to the 1918 National League pennant and a World Series loss to the Red Sox. He returned to Boston in 1921 and managed the Braves until 1923. His teams finished in fourth, eighth, and seventh place during his tenure. Mitchell later directed the Harvard University baseball program for many years. (J. Brooks.)

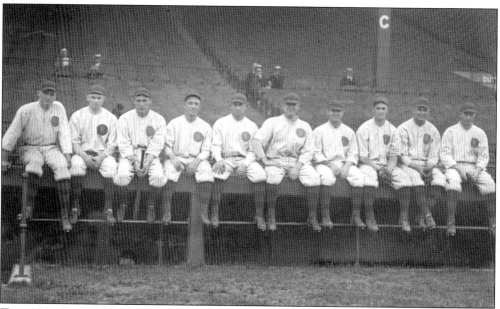

THE 1916 BRAVES PITCHING STAFF AT BRAVES FIELD. Pictured from left to right are Bill James, "No Hit" Davis, Tom Hughes, Frank Allen, Art Nehf, Pat Ragan, Dick Rudolph, George Tyler, Ed Reulbach, and Jess Barnes.

The 1916 Braves won just five fewer games than their miraculous counterparts of 1914 and finished in third place. Rudolph led the staff with 19 wins, with Lefty Tyler and Tom Hughes contributing 17 and 16 victories, respectively. (G. Sullivan.)

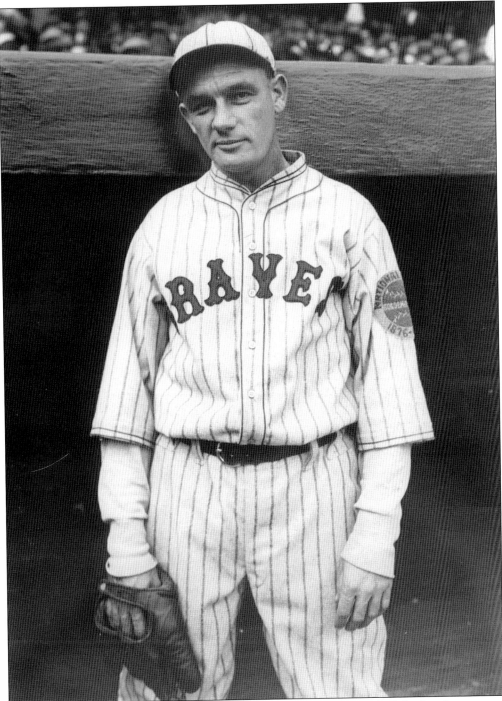

RICHARD "RUBE" MARQUARD. Veteran pitcher Rube Marquard pitched the last four seasons of his Hall of Fame career with the Braves. In Boston, he won 25 games and lost 39 for a team that finished at or near the cellar of the National League during his tenure. He was reunited with the legendary Christy Mathewson, a New York Giant teammate from 1908 to 1915, when Mathewson served as Braves president in 1923. (G. Altison.)

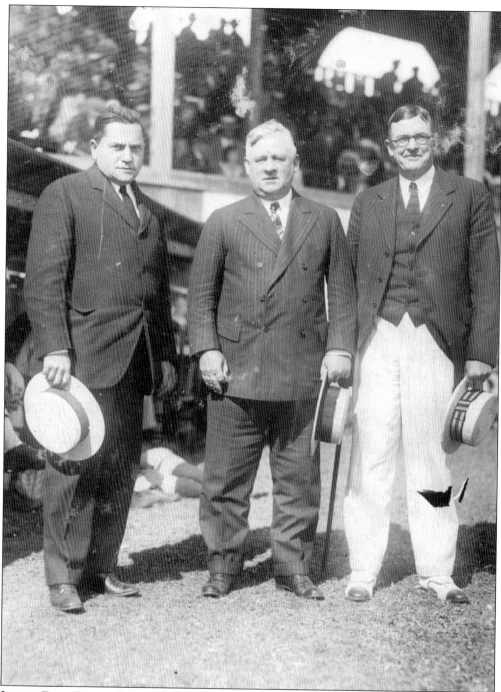

JUDGE EMIL FUCHS, JOHN MCGRAW, AND CHRISTY MATHEWSON IN ST. PETERSBURG, FLORIDA, C. 1923. Legendary New York Giants manager John McGraw meets with his former star pitcher and Braves president Christy Mathewson as well as Braves owner Emil Fuchs at the Braves spring training camp in March 1923. Within two years, Mathewson died of tuberculosis and the effects of having been gassed in the trenches in World War I. (G. Altison.)

Five

THE JUDGE, THE DEACON, AND THE BABE, 1923–1936

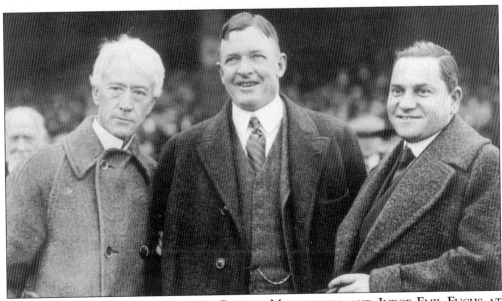

JUDGE KENESAW MOUNTAIN LANDIS, CHRISTY MATHEWSON, AND JUDGE EMIL FUCHS AT BRAVES FIELD, C. 1923. Former Giant pitching great Christy Mathewson returned to baseball in 1923 after having been treated at Saranac Lake for acute tuberculosis. His health rapidly declined after he was exposed to poison gas on the western front while serving in World War I. In 1923, he accepted the position of president of the Boston Braves, which he held until his death in 1925 at age 45. (SMNE.)

LANCE RICHBOURG, C. 1927. In five seasons with the Braves, right fielder Lance Richbourg batted a solid .311 with 64 stolen bases. The Florida native, who held a steady, full-time job while playing for the team, was particularly noted for his superb fielding, despite hitting only 12 home runs in his tenure with the Braves. (G. Altison.)

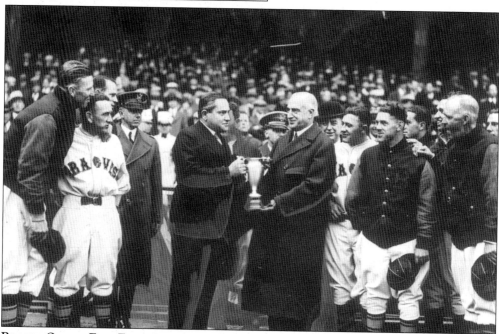

BRAVES OWNER EMIL FUCHS AND MASSACHUSETTS GOVERNOR FRANK G. ALLEN, APRIL 19, 1929. In 1929, Braves owner Emil Fuchs, a former federal judge, not only signed his player's paychecks but managed the team as well. He would arrive at the ballpark from his law offices and ask coach and future Hall of Famer Dave "Beauty" Bancroft, "What shall we try today?" Despite his efforts, the team finished in last place a whopping 43 games behind the Chicago Cubs. (Boston Herald.)

ROGERS HORNSBY, C. 1928. In his only season as a Brave, Rogers Hornsby electrified Boston by winning his seventh National League batting championship with an average of .387. Hornsby also led the league in walks (107) and slugging percentage (.632). New York Giant manager John McGraw was so afraid that Hornsby was undermining his authority that he let his superstar go to the Boston Braves in a trade for catching prospect Shanty Hogan and outfielder Jimmie Welsh. (SMNE.)

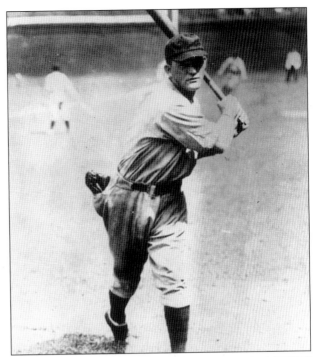

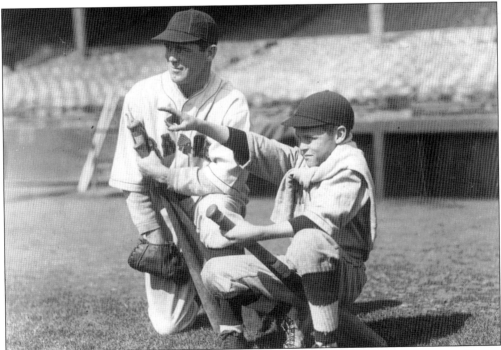

GEORGE SISLER SR. AND GEORGE SISLER JR., C. 1929. Hall of Fame first baseman George Sisler Sr. played the final three seasons of his Major League career with the Braves and batted .326 in 388 games. His son George later served as president of the International League for many years. His other sons, Dave and Dick, played in the majors. Dick socked a pennant-clinching home run for the Philadelphia Phillies in 1950. (G. Altison.)

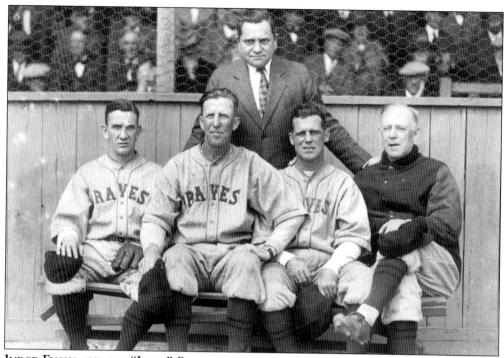

JUDGE FUCHS AND HIS "JURY." Braves owner-manager Judge Emil Fuchs (standing) is shown at the team's St. Petersburg spring training headquarters. Sitting, from left to right, are coaches Rabbit Maranville (also served as a player), Hank Gowdy, George Sisler, and Johnny Evers. Of the coaching staff, only Gowdy (the hitting star of the 1914 World Series) was not a future Hall of Famer. (G. Sullivan.)

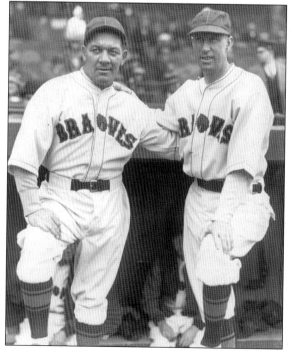

PAT COLLINS AND "JUMPING" JOE DUGAN AT BRAVES FIELD, C. 1929. Former Yankee stars Collins and Dugan were reunited with the Boston Braves in 1929. Both saw limited service, with Dugan batting .304 in 60 games and Collins batting .000 in seven games.

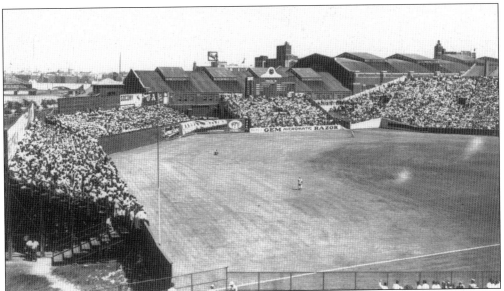

BRAVES FIELD, C. 1930. Braves Field—originally a power hitter's nightmare, with its 550-foot center field and 500-foot power allies—was reconfigured several times to accommodate hometown heroes such as Shanty Hogan. In 1930, the Braves placed temporary bleachers in left field to attract both fans and home runs. (SMNE.)

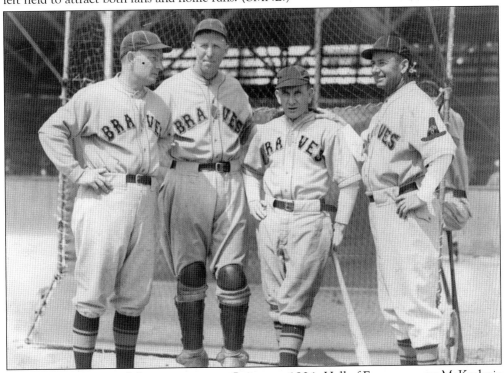

MCKECHNIE, GOWDY, MARANVILLE, AND LEWIS, C. 1931. Hall of Fame manager McKechnie greets coaches Hank Gowdy, Duffy Lewis, and fellow Hall of Famer Rabbit Maranville in St. Petersburg. Note the pilgrim hat patch on Lewis's left sleeve, which commemorates the city of Boston's 300th anniversary. (G. Sullivan.)

BRAVES COACH DUFFY LEWIS, c. 1931. Former Red Sox left fielder Duffy Lewis served the Braves in Boston and in Milwaukee as coach, traveling secretary, and roving goodwill ambassador. For decades, he was considered the sharpest dresser in baseball. (G. Sullivan.)

ART SHIRES AND AL SPOHRER, SPRING TRAINING 1932. Art Shires, always the flamboyant showman, greets new teammate and former boxing opponent Al Spohrer at St. Petersburg in March 1932. Two years earlier, on January 30, 1930, Shires beat Spohrer in a four-round bout before a packed house at Boston Garden. His next bout against Cub slugger Hack Wilson was stopped by baseball commissioner Kenesaw Mountain Landis in the best interests of baseball. (J. Brooks.)

PITCHER WALTER "HUCK" BETTS,
c. 1934. Right-hander Huck Betts
proved a solid starter for the Braves
from 1932 through 1934. These were
his three best seasons in his decade-
long Major League career. During this
stretch, he won 13, 11, and 17 games,
respectively, before arm trouble forced
his retirement in 1935. (G. Altison.)

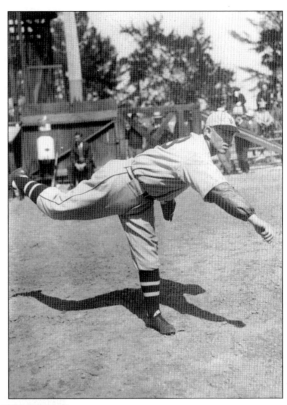

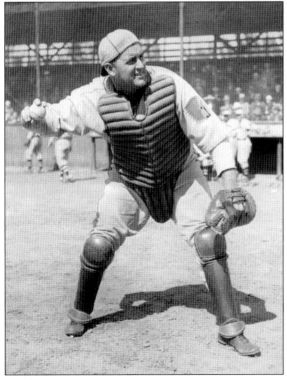

FRANK "SHANTY" HOGAN. A
native of Somerville, Hogan was an
imposing figure on the diamond,
standing six feet, one inch tall and
weighing more than 250 pounds. He
played for the Braves from 1925 to
1927 and again from 1933 to 1935.
In 13 Major League seasons, Hogan
batted .295. (G. Altison.)

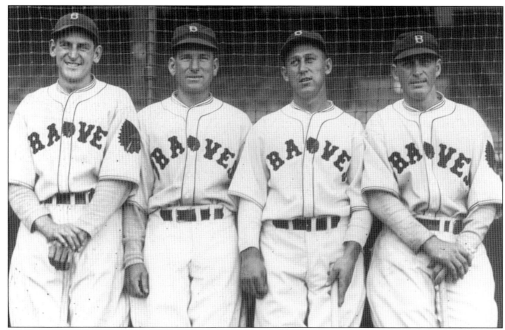

BAXTER JORDAN, PINKEY WHITNEY, BILL URBANSKI, AND MARTY MCMANUS, C. 1934. The infield of the 1934 Braves featured Jordan at first, McManus at second, Urbanski at shortstop, and Whitney at third. McManus was a replacement for veteran Rabbit Maranville, who broke his leg while attempting a double steal in spring training. Jordan helped the Braves to a fourth-place finish and led the team in batting at .311, with Urbanski close behind with an average of .293. (J. Brooks.)

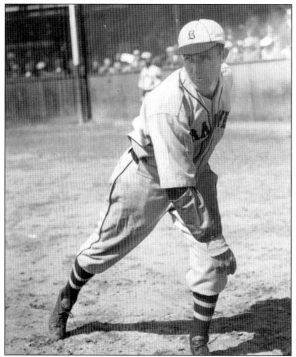

PITCHER BOB BROWN, C. 1934. Dorchester native Bob Brown showed enormous promise as a rookie in 1932. He won 14 games with 7 losses and a 3.30 ERA. However, the right-hander won just 2 more games and lost 14 in his 4 remaining seasons with the team, 1933 through 1936. (G. Altison.)

ELBIE FLETCHER AT SPRING TRAINING, 1934. Elburt Fletcher was so new to the sport in 1934 that reporters listed him as "Albert" Fletcher, until the shy member of the Milton High School baseball team corrected them at long last. Fletcher had won his trip to spring training by winning an essay contest and was soon discovered to be more skilled with his bat than with his pen. (J. Brooks.)

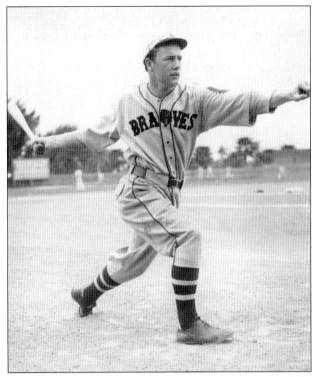

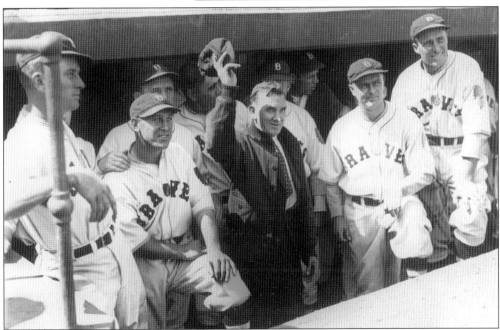

RABBIT MARANVILLE, SEPTEMBER 2, 1934. In his 23rd Major League season, shortstop Rabbit Maranville was welcomed back to Braves Field as his recovery from a badly broken leg continued. His injury had forced him to miss the entire campaign. Maranville, along with Tommy Holmes and Johnny Cooney, was considered one of Braves Field's all-time favorites. (G. Altison.)

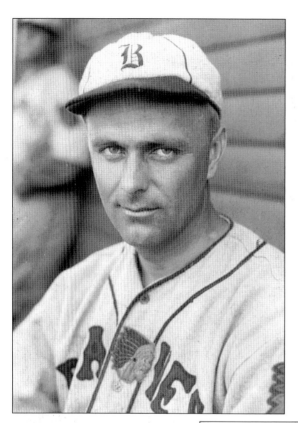

FRED FRANKHOUSE, C. 1934.
Right-hander Fred Frankhouse
arrived in Boston via a trade with the
St. Louis Cardinals for future Hall
of Fame pitcher Burleigh Grimes.
Frankhouse anchored the Braves staff
for five seasons. His best year was
1934, when he won 17 games and lost
9. (G.Altison.)

**WALLY BERGER COMPLETES A
HOME RUN, C. 1935.** Wally
Berger stands as the greatest
slugger in Boston Braves history,
as he clouted 199 home runs
in eight seasons. Not only did
he hit home runs in quantity,
but he was also forced to hit
most of his home runs the
proverbial "country mile," the
large expanse of Braves Field,
against a prevailing north wind.
His rookie home run record of
38 was tied by Frank Robinson
in 1956 and was later broken by
Mark McGwire with 49 in
1987. (G. Altison.)

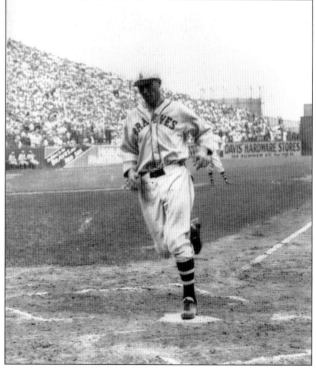

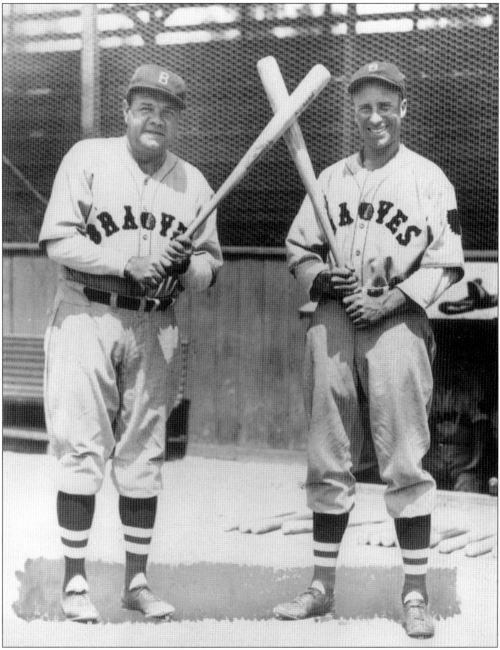

BABE RUTH AND WALLY BERGER, C. 1935. Slugger Wally Berger is shown with Babe Ruth in 1935 at spring training in St. Petersburg, Florida. While Ruth was dominating headlines with his legendary successes, Berger was leading the hapless Braves in their worst season ever. Berger did, however, lead the National league in home runs with 34 and RBIs with 130. (NBHF.)

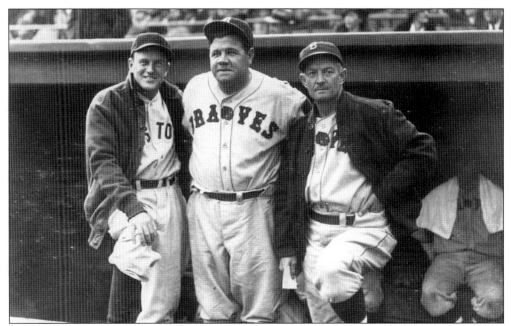

JOE CRONIN, BABE RUTH, AND BILL MCKECHNIE AT BRAVES FIELD, APRIL 14, 1935. Before the start of the traditional preseason series between the Red Sox and Braves at Braves Field, newly signed slugger Babe Ruth greets Red Sox manager Joe Cronin and Braves manager Bill McKechnie. It was the start of Ruth's short-lived Boston comeback, which ended roughly a month later when the slugger quit baseball for good. (J. Brooks.)

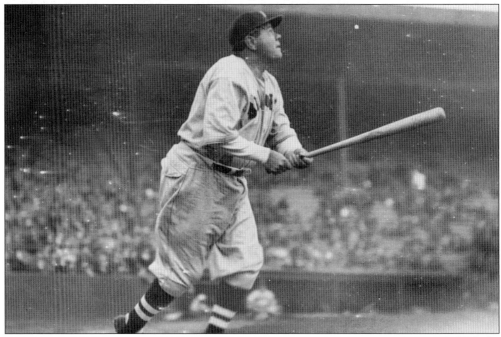

BABE RUTH FACES THE RED SOX, APRIL 14, 1935. In a preseason game at Braves Field, Babe Ruth flies out with two men on base in the fifth inning of the Braves' 3-2 victory over the Red Sox in their traditional preseason exhibition series. (J. Brooks.)

54

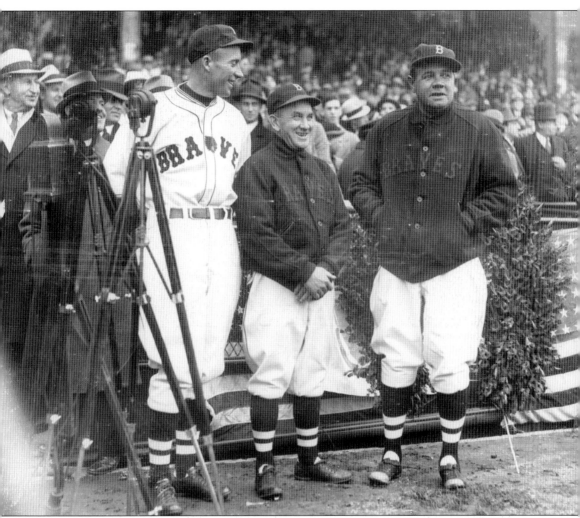

WALLY BERGER, RABBIT MARANVILLE, AND BABE RUTH ON OPENING DAY, 1935. In 1935, Babe Ruth helped the Braves sell tickets in April and May before his early retirement. It was slugger Wally Berger, however, who remained the main attraction for one of baseball's worst teams. Although the Braves lost an astonishing 115 games, Berger led the National League in home runs with 34 and RBIs with 130. Rabbit Maranville, in his 23rd season, broke his leg after only 23 games and announced his retirement soon afterward. (D. Brearley.)

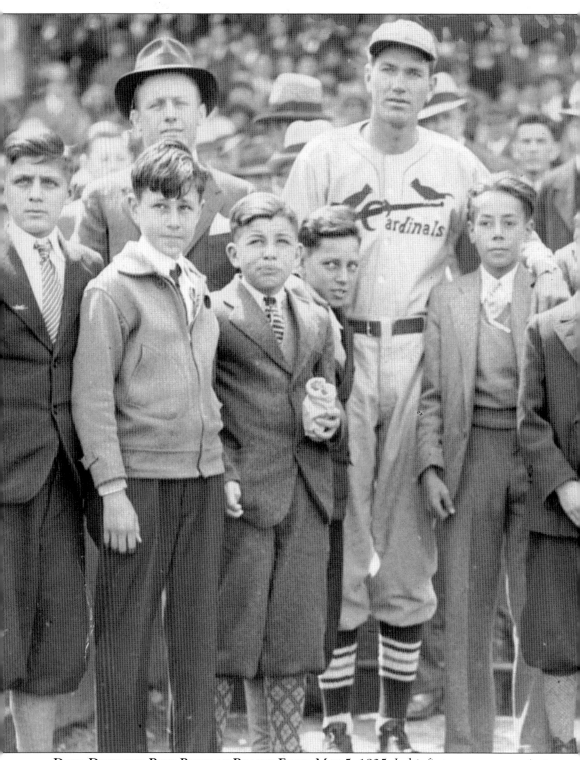

DIZZY DEAN AND BABE RUTH AT BRAVES FIELD, MAY 5, 1935. In his first appearance against fellow Hall of Famer Dizzy Dean, Babe Ruth struck out, walked, and grounded out. Prior to the

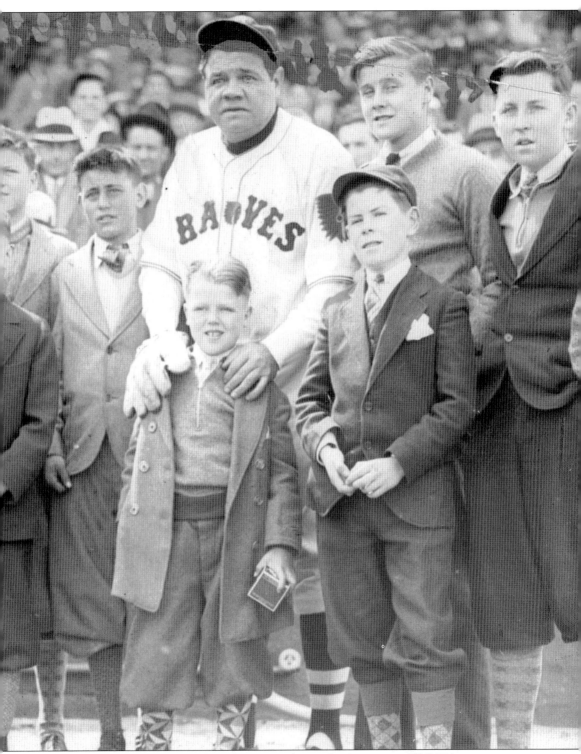

game, the two greeted fans and shared stories with a mob of reporters. (SMNE.)

THE 1935 NEW YORK BASEBALL WRITERS DINNER. National League president Ford Frick presents Rabbit Maranville and Dizzy Dean with their awards. Maranville was honored with the Award of Merit from the New York Chapter of the Baseball Writers of America, and Dizzy Dean of the Cardinals received the award for Player of the Year from Ford Frick at the Waldorf-Astoria Hotel. (J. Brooks.)

JUDGE FUCHS DAY PROGRAM, APRIL 16, 1935. Prior to a game between the Giants and Braves at Braves Field, Judge Emil Fuchs was honored with the presentation of a bronze plaque, which honored his tenure as club owner. (Author's collection.)

Six

LAND OF THE BEES, HOME OF THE BRAVES, 1936–1942

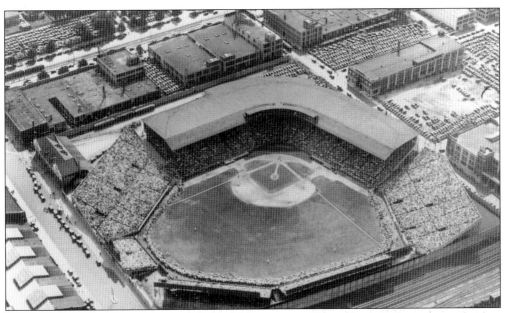

BRAVES FIELD, C. 1936. This aerial view shows a rare sellout at Braves Field. Note the fans clustered on the field alongside the temporary outfield fences. Legend has it that Braves outfielder Wally Berger once socked a home run that bounced into a boxcar and ended up in Chicago, where a worker discovered the ball. Sportswriters soon dubbed it the longest home run in baseball history. (SMNE.)

THE 1936 ALL-STAR GAME PROGRAM. The Boston Braves, now known as the Boston Bees as the result of a newspaper-sponsored team-renaming contest, hosted the fourth All-Star game and, due to an administrative error, ended up attracting a crowd of nearly 7,000 under capacity. The National League, thanks to an error by rookie Joe DiMaggio, won their first All-Star game by a score of 4-3. Typical of their modest setup, the Braves used a regular season scorecard for the game with a stapled All-Star lineup. (G. Altison.)

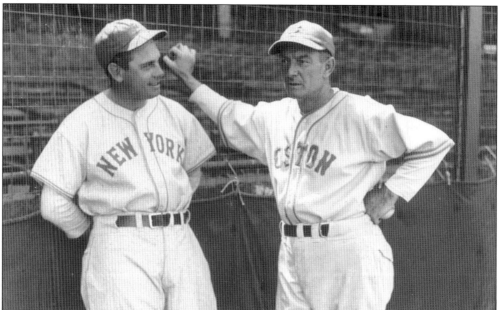

GIANTS MANAGER BILL TERRY AND BRAVES MANAGER BILL MCKECHNIE, C. 1937. Bill McKechnie was named to the National Baseball Hall of Fame despite the fact that for eight seasons his Boston Braves and Bees languished near the bottom of the National League. Despite their standing, he actually turned a hopeless franchise into a respected team. In 1937, McKechnie helped rookie pitchers Jim Turner and Lou Fette win 20 games apiece. The Reds soon hired him and, within two seasons, he had taken a last-place team to consecutive World Series in 1939 and 1940. (Maxwell Collection.)

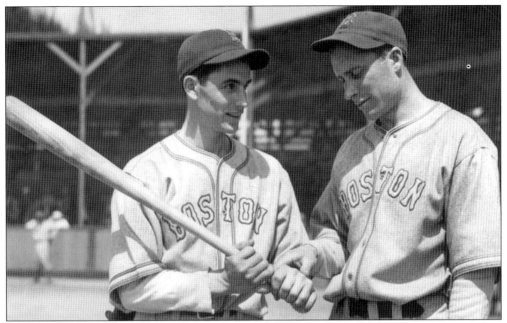

VINCE DIMAGGIO AND WALLY BERGER, MARCH 1937. Veteran slugger Wally Berger gives batting tips to Vince DiMaggio at the Bees' St. Petersburg training camp. DiMaggio, a former star with the San Diego Padres of the Pacific Coast League, soon joined Berger as a starter in the Bees outfield.

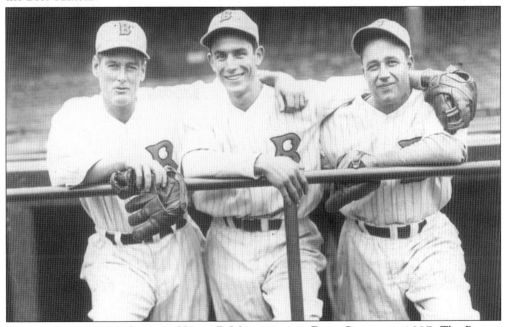

FRANK "BEAUTY" MCGOWAN, VINCE DIMAGGIO, AND DEBS GARMS, C. 1937. The Boston Bees outfield featured Vince DiMaggio in center, Debs Garms in left field, and Gene Moore in right field. Frank "Beauty" McGowan joined the team as a substitute outfielder for just nine games after a hiatus of nine years from the Major Leagues. In 12 at-bats, the Connecticut native batted only .083. (J. Brooks.)

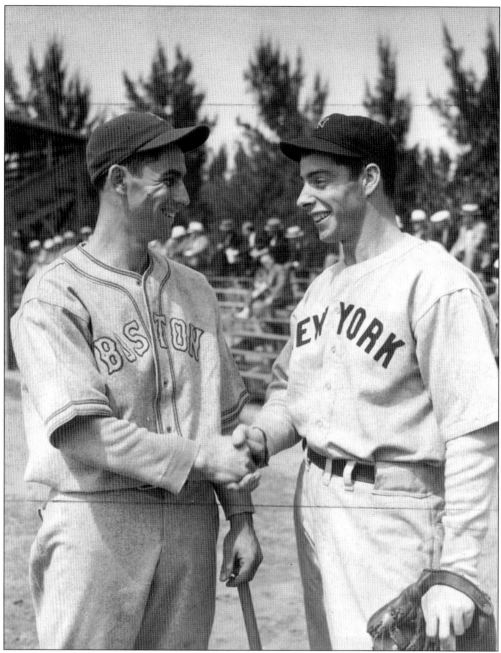

VINCE AND JOE DiMAGGIO, SPRING TRAINING, C. 1937. Joe DiMaggio was already the toast of America by the time his older brother arrived at St. Petersburg to attempt to win a starting outfield position with the Braves. Vince eventually started in center field and ended up spending a decade in the majors. (G. Sullivan.)

VINCE DiMAGGIO, c. 1937. Like his brother Dominic, Vince DiMaggio also wore glasses. However, unlike either of his baseball-playing brothers, Vince was incredibly prone to striking out and set the National League record of 111 in his rookie season of 1937. He broke his mark the following season with 134. (G. Sullivan.)

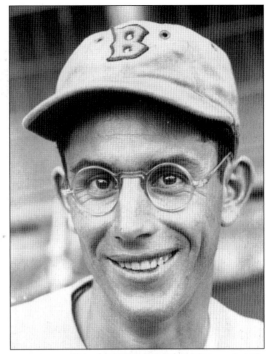

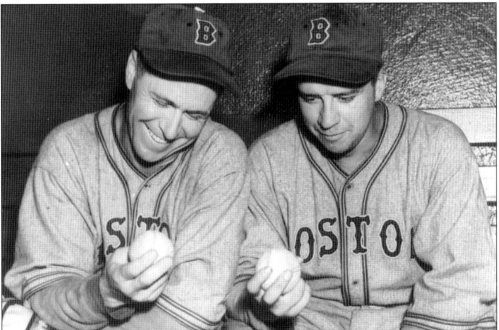

JIM TURNER AND LOU FETTE, c. 1937. Pitchers Lou Fette and Jim Turner were overnight rookie sensations for the Bees in 1937, as both won 20 games (including Fette's league-leading five shutouts). What made their feat all the more outstanding was the notoriously weak offensive support of their team as well as the fact that Turner was 34 years old at the end of the season and Fette was 30. Turner would later serve as longtime New York Yankee pitching coach. (G. Altison.)

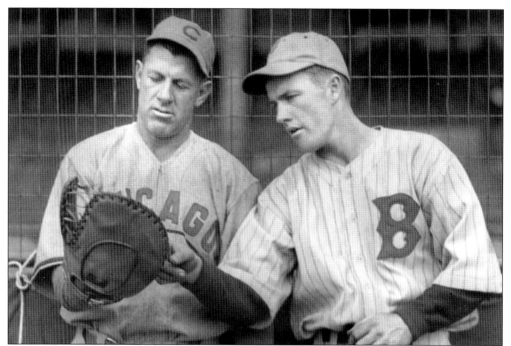

CHARLIE GRIMM AND ELBIE FLETCHER AT BRAVES FIELD, C. 1938. By 1938, 22-year-old Elbie Fletcher had already spent parts of four seasons with the Braves and had established himself as the club's starting first baseman. In 1938, he batted .272, a figure nearly identical to his .271 lifetime batting average.

DUELING FIRST BASEMEN AT SPRING TRAINING, C. 1939. Buddy Hassett, left, is posed in a mock duel with rival first baseman Elbie Fletcher as Bees manager Casey Stengel observes the proceedings. Before the end of the 1939 season, Fletcher was traded to the Pirates and Hassett batted . 308 in 147 games as Bees' first baseman. (G. Sullivan.)

BOB AND JOHN REIS OF THE BOSTON BEES, C. 1937. Brothers Bob and John Reis were one of the few brother battery pairs in baseball. They were soon compared to the Ferrell brothers of the Red Sox. Unlike the Ferrells, however, the Reis brothers never appeared together in a Major League game, and only Bob made the majors as a utility pitcher and outfielder. (G. Sullivan.)

ROGER "DOC" CRAMER AND WALLY BERGER, C. 1937. Red Sox right fielder Doc Cramer and Braves slugger Wally Berger are shown posing prior to a city series game. Both were superb hitters; Cramer was a superior singles hitter and Berger was the Bees' home run hero. (G. Sullivan.)

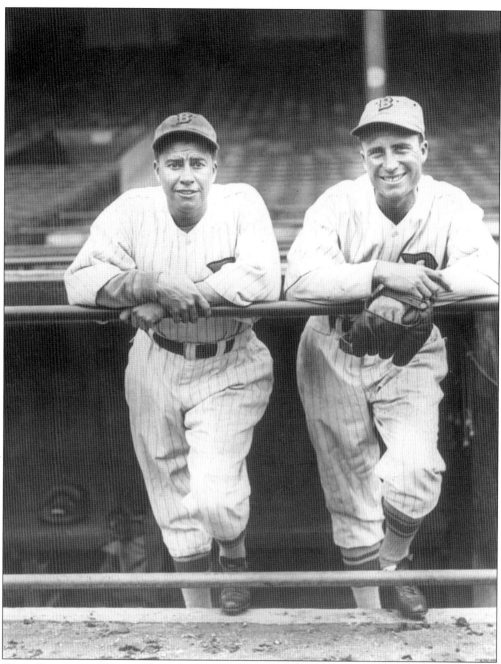

LOU FETTE AND WALLY BERGER AT BRAVES FIELD, C. 1937. As a 30-year-old rookie in 1937, right-hander Lou Fette won 20 games for the Braves. On June 15, 1937, the Braves traded longtime fan favorite Wally Berger to the Giants for $30,000 and a journeyman pitcher named Frank Gabler. With the loss of Berger, even Fette could not help the Braves finish above fifth, despite the team having lead the league in ERA (3.22) and fielding percentage (.975).

JOE CRONIN AND CASEY STENGEL AT SARASOTA FLORIDA, 1939. Hall of Famers Casey Stengel and Joe Cronin confer prior to a Red Sox/Bees spring training game. Among the stories dominating spring training that season was the emergence of a Red Sox rookie named Ted Williams. (G. Sullivan.)

AL LOPEZ AND JIM TURNER, C. 1939. The Braves Opening Day battery for 1939 was Hall of Fame catcher Al Lopez and pitcher Jim Turner. Lopez later managed both the Indians and White Sox to pennants in the 1950s, and turner served for many years as Yankee pitching coach. (G. Sullivan.)

BOSTON BEES AT SPRING TRAINING, C. 1938. Shown from left to right are Elbie Fletcher, Tom Reis, Bill Weir, Debs Garms, Danny MacFayden, Ivy Andrews, Casey Stengel, and Ralph Macleod.

PITCHER DANNY MACFAYDEN AND OUTFIELDER AL SIMMONS, C. 1939. Outfielder Al Simmons was one of the many Hall of Famers to spend one season with the franchise. The former Philadelphia Athletics star played just 93 games with the club while batting a respectable .282, a full 52 percentage points below his lifetime batting average. MacFayden enjoyed a won-lost record of 8 and 14 with an ERA of 3.90 in his 14th Major League season. (G. Altison.)

CASEY STENGEL IN THE RAIN. Bees manager Casey Stengel appeals to the umpires to call the second game of a double-header against the Giants at the Polo Grounds on August 9, 1939. Such antics endeared him to fans but irritated a Boston press corps weary of watching his perpetual losses. (G. Altison.)

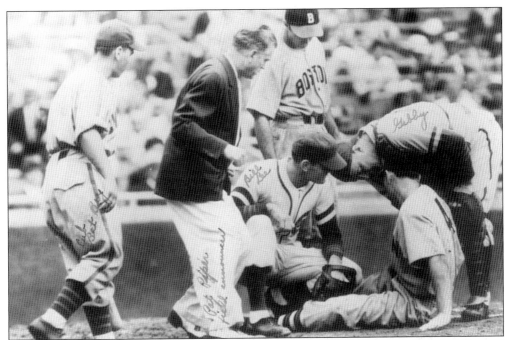

MAX WEST INJURED AGAINST THE CUBS, JULY 11, 1940. Shortly after leading the National League to victory in the 1940 All-Star game with a first-inning home run off Red Ruffing, Braves right fielder Max West crashed into the wall at Sportsmans Park and was forced to leave the game. Days later West was injured at Wrigley Field as he slid into Cubs catcher Gabby Hartnett.

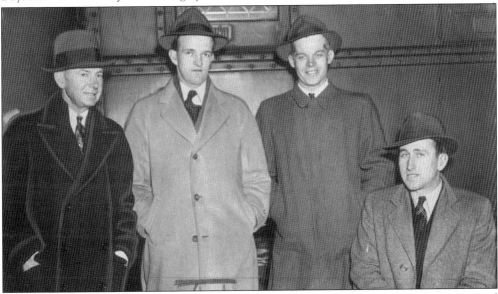

DUFFY LEWIS, GEORGE BARNICLE, AND ART JOHNSON, C. 1941. Duffy Lewis and Massachusetts natives George Barnicle (Fitchburg), Art Johnson (Winchester), and Stanley Andrews (Lynn) are shown on their way to spring training. Former Red Sox star Lewis not only served as the Braves' traveling secretary but also helped rookies become professionals both on and off the field. There is no doubt that Lewis shared pointers regarding dress, tipping, and overall behavior with these young players. (G. Sullivan.)

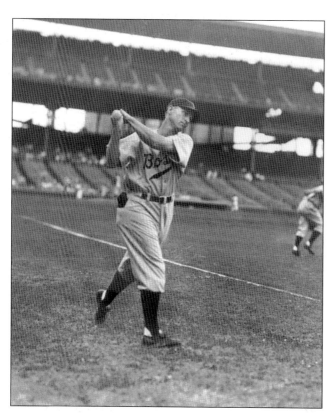

GENE MOORE, C. 1941. As a rookie in 1936, right fielder Gene Moore led the National League in assists with 32 while batting a solid .290 with 13 home runs, 91 runs, 38 doubles, and 67 RBIs. The following season saw him achieve a career high of 16 home runs and 70 RBIs and again led the league in assists. Moore spent 5 of his 14 Major League seasons with the Braves.

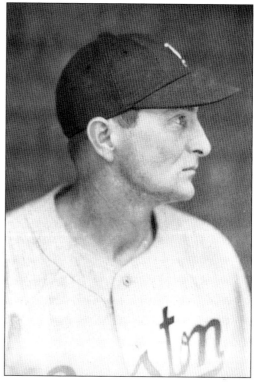

PAUL "BIG POISON" WANER, C. 1941. Hall of Famer Paul Waner played for a portion of the 1941 season and the entire 1942 season with the Braves. In his 209 games for the team, he batted .268, or a full 65 points below his career batting average. During his limited stint in Boston, Waner helped tutor such batters as Tommy Holmes on the finer points of hitting. In 1941, his brother and fellow Hall of Famer Lloyd Waner joined him as a teammate for 19 games. (Author's collection.)

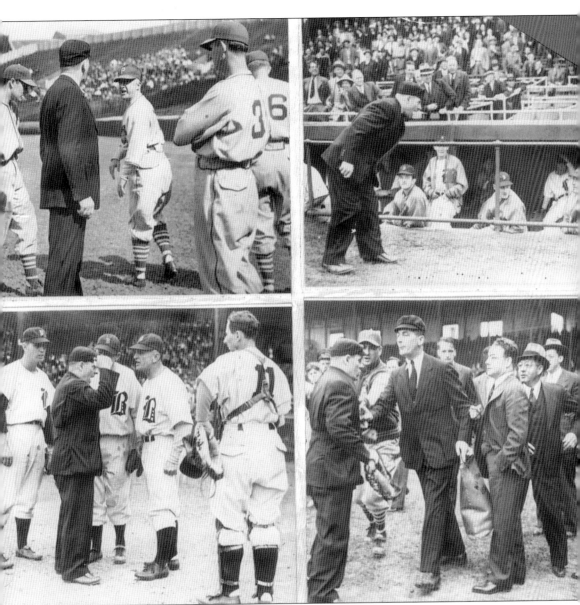

UMPIRES BILL DUNN AND BILL STEWART AT BRAVES FIELD, MAY 9, 1941. The Braves-Pirates game of May 9, 1941, was the scene of several rhubarbs. Included among the confrontations was the one that Bill Stewart had with Pirates manager Frankie Frisch (top left), Braves manager Casey Stengel (lower left), and angry Braves fans (lower right). (G. Sullivan.)

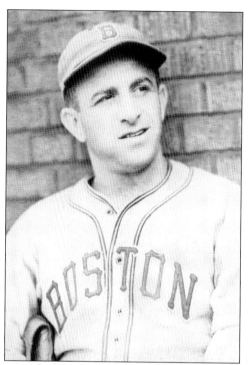

ANTHONY "CHICK" CUCCINELLO. Anthony Cuccinello anchored second base for the Boston Bees from 1936 to 1940 and again in 1942 after returning from the New York Giants. An ankle injury that he suffered in 1939 hindered the remainder of his 15-year Major League career, which ended in 1945. (Author's collection.)

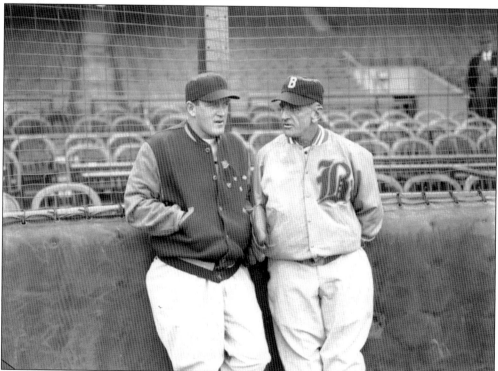

JOE CRONIN AND CASEY STENGEL, C. 1940. Both Stengel and Cronin gained immortality in the National Baseball Hall of Fame. Cronin earned his spot primarily as a player and Stengel as one of baseball's greatest managers, based on everything except his years as manager of the Braves.

Seven

THE THREE STEAM SHOVELS, 1942–1948

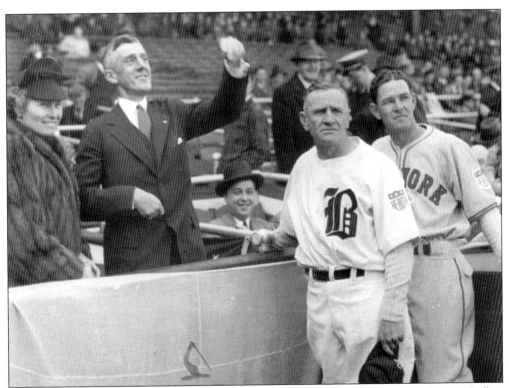

OPENING DAY, 1942. Massachusetts governor Leverett Saltonstall tosses out the first ball at a less-than-filled Braves Field in front of Braves manager Casey Stengel and Giants player-manager Mel Ott. For the entire season, the team drew only 285,332 fans, an average of only 3,705 spectators per game. (J. Brooks.)

TOMMY HOLMES AT SPRING TRAINING, C. 1942. After starring with the Newark Triple A farm team of the New York Yankees, Tommy Holmes finally received his chance at the majors after being traded to the Boston Braves. Not only did he make the team but soon became a fan favorite as the Braves right fielder. (J. Brooks.)

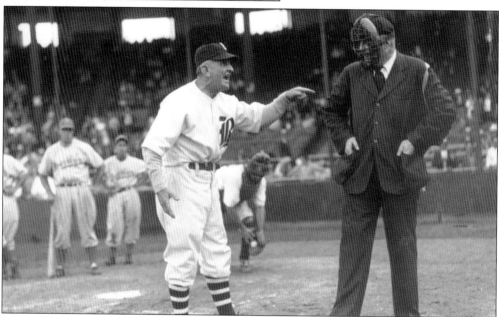

CASEY STENGEL MAKES HIS ARGUMENT, C. 1942. In 1938, Casey Stengel succeeded fellow Hall of Famer Bill Mckechnie as manager of the then-Boston Bees. In five and a half seasons, his best finish was fifth place in 1938. The remainder of his tenure saw the team lose an average of 90 games a season while perpetually mired in seventh place. Hall of Famer Warren Spahn, who pitched for Stengel on both the Braves and Mets, would remark that he "played for Casey before and after he was a genius." (Maxwell Collection.)

CHET ROSS, C. 1942. In his rookie season of 1940, outfielder Chet Ross made a big impression by leading the Braves in home runs with 17 and RBIs with 89. However, the young slugger also struck out 127 times and only socked six home runs for the rest of his injury-plagued six-year career, which was spent entirely with the Braves. (G. Sullivan.)

FRIOLAN "NANNY" FERNANDEZ, C. 1942. At the end of April 1942, Braves rookie third baseman Nanny Fernandez led the National League with 22 hits after socking a double and three singles in a game against the Cubs in Chicago on April 28. His arrival in Boston came after he led the Pacific Coast League in hits, total bases, and RBIs for the 1941 season. (J. Brooks.)

JOHNNY COONEY, C. 1942. Johnny Cooney spent 15 of his 20 Major League seasons with the Boston Braves. The son and brother of Major League shortstops started his career as a pitcher and won 34 games before an operation shortened both his arm and pitching career. Reborn as an outfielder, Cooney batted .286 in 1,172 games. So respected was Cooney that he once umpired a game with the Giants in Boston when the boat carrying the umpires failed to make it to Boston. Both teams agreed that he had called a fair game in his unprecedented and unexpected position. (Maxwell Collection.)

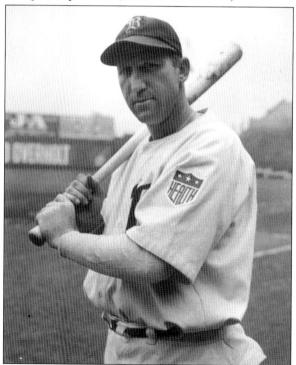

PITCHER JIM TOBIN, C. 1942. On May 12, 1942, manager Casey Stengel called upon pitcher Jim Tobin to pinch hit in a game against the Phillies at Braves Field, where he socked a home run. The next day, in his start against the Cubs in Boston, the right-hander clouted three home runs to become the only pitcher in the 20th century to accomplish the feat. He finished the season with six home runs, one per every 19 at-bats. This feat compared almost identically with Mel Ott, who led the league in home runs with one every 18.3 at-bats. (G. Altison.)

WILLIAM "WHITEY" WIETELMANN, C. 1942. In eight seasons with the Braves, Whitey Wietelmann won the starting shortstop job from 1943 until 1946. In 1946, he suffered a career-ending injury while pitching at batting practice. He accidentally stopped a line drive with his throwing hand and lost the use of a finger as a result of a severe fracture and an on-the-field partial amputation. (J. Brooks.)

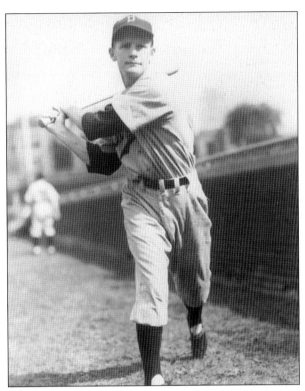

SHORTSTOP EDDIE MILLER, C. 1942. For three consecutive seasons (1940–1942), shortstop Eddie Miller was a member of the National League All-Star team. Acquired from the Reds in a 1938 trade that sent Vince DiMaggio to Cincinnati, Miller was considered one of the best young shortstops in baseball and even received 38 votes for National League MVP in 1940. (Author's collection.)

THE 1943 SPRING TRAINING AT CHOATE SCHOOL, WALLINGFORD, CONNECTICUT.
Outfielder Tommy Holmes, left, and first baseman John J. McCarthy enjoy the amenities of
the Choate School in Wallingford, Connecticut, where the Braves held spring training in
the depths of World War II. Most other Major League teams held spring training at similar
northern locations during the war.

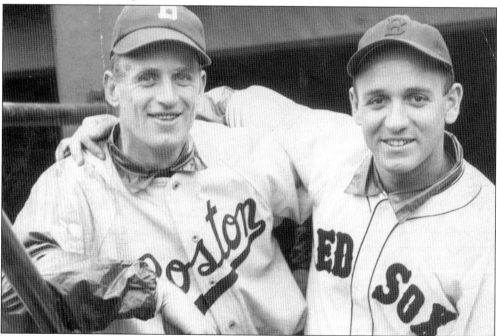

CREEDEN AND LUPIEN, C. 1943. Posing at Fenway Park before a game are opposing first
basemen Connie Creeden of the Braves and Tony Lupien of the Red Sox. Lupien, a Harvard
graduate, later taught and coached baseball at Dartmouth College while Creeden enjoyed a
five-game "cup of coffee" in 1943. Creeden's .250 career batting average was the result of just
one hit in four Major League at-bats. (G. Sullivan.)

80

FRANKIE FRISCH PRESENTS FLOWERS TO BRAVES MANAGER CASEY STENGEL, C. 1943. In an oft-recalled anecdote, Boston sports columnist Dave "the Colonel" Egan nominated the cab driver who struck Braves manager Casey Stengel as Man of the Year. Egan had made the colorful but unsuccessful Stengel a frequent target in his widely read column. Stengel suffered a broken leg as a result of the mishap and is shown here at St. Elizabeth's Hospital in Boston with his old friend and fellow Hall of Famer Frankie Frisch. (G. Altison.)

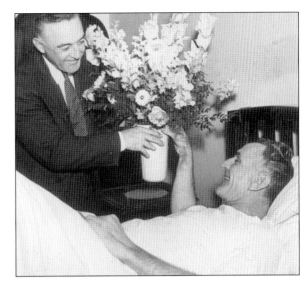

CASEY STENGEL JOHN MCCARTHY, C. 1943. The 1943 Braves possessed such a thin roster that when first baseman Johnny McCarthy broke his ankle in mid-season, he was replaced by pitcher Kerby Ferrell. Stengel could only manage to lead his war-ravaged lineup to a sixth place finish, $36^1/2$ games behind the Cardinals. (G. Altison.)

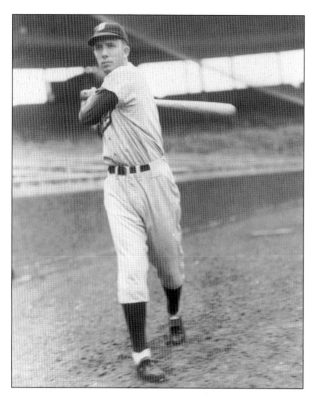

CHUCK WORKMAN, C. 1943. Third baseman and outfielder Chuck Workman enjoyed a career season in 1945, when he hit 25 home runs and drove in 87 runs for the sixth-place Braves. (J. Brooks.)

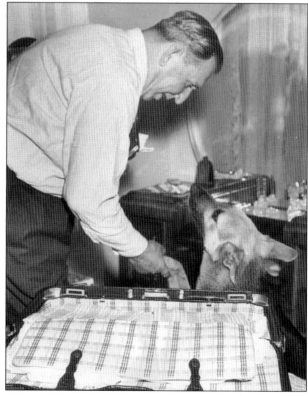

BRAVES MANAGER BOB COLEMAN PACKS FOR SPRING TRAINING, C. 1945. Longtime Minor League manager and Major League coach Bob Coleman succeeded Casey Stengel following the Braves sixth-place finish in 1943. Coleman is shown here at his home in Evansville, Indiana, with his dog Silver. Coleman managed to keep the Braves in sixth place for 1944 and 1945 before being replaced as manager by coach Del Bissonette before the end of the 1945 season. (G. Altison.)

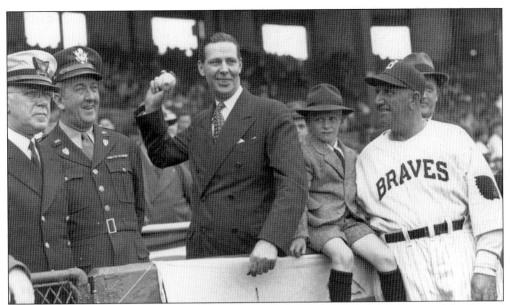

OPENING DAY, 1945. Massachusetts governor Maurice Tobin, center, is joined by Braves manager Bob Coleman, right, for the ceremonial first pitch to open the Braves 70th season in Boston. Coleman was fired midway through the season after having achieved a mediocre 128-165 won-lost record in a little more than two seasons managing the Braves. (SMNE.)

MAX WEST, C. 1946. In his sole All-Star game appearance in 1940, Max West made history by socking a three-run first inning home run off Red Ruffing at Sportsman's Park to help lead the National League to a 4-0 victory. In six seasons with the Braves, West played outfield and first base and batted a solid .283. (SMNE, Rucker Donation.)

"BIG" BILL LEE, C. 1946. Standing an imposing six feet, three inches tall, right-hander Bill Lee, known by his nicknames of "Big Bill" and "General Lee," was a 20-game winner and star with the Chicago Cubs. By the time he arrived in Boston in 1945, Lee had been forced to wear eyeglasses because of persistent eye problems. In two seasons with the Braves, Lee achieved a won-lost record of 16-9. Following his career, he eventually lost his sight as the result of two detached retinas. (J. Brooks.)

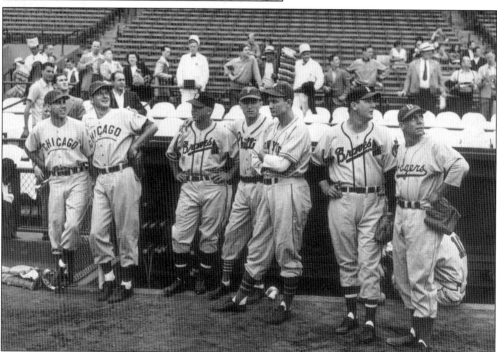

NATIONAL LEAGUE ALL-STARS AT FENWAY PARK, C. 1946. Among the National League stars watching Ted Williams take batting practice are, from left to right, Harry "Peanuts" Lowrey, Bob Scheffing, Johnny Hopp (Braves), Emil Verban, Walker Cooper, Mort Cooper (Braves), and Kirby Higby. (G. Sullivan.)

SECOND BASEMAN CONNIE RYAN, C. 1947.
Second baseman Connie Ryan was named
to the 1944 National League All-Star team
shortly before leaving for service in World
War II. When he returned to Boston prior to
the start of the 1946 season, Ryan won back
his job for two seasons before the arrival of
Eddie Stanky via a trade from the Dodgers.
The remainder of Ryan's career was spent in
utility service. (Author's collection.)

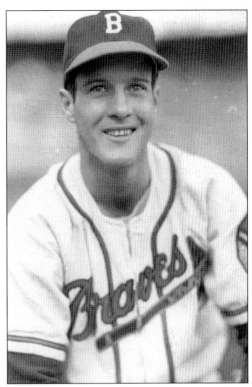

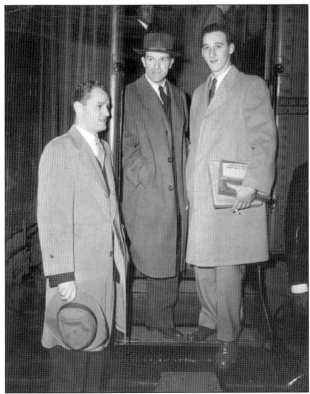

WALTER LANFRANCONI,
SPORTSWRITER GORDON
CAMPBELL, AND WARREN
SPAHN, C. 1947. The 1940s were
the last decade in which baseball
teams traveled predominantly by
train. It was also an era in which
players interacted more with
beat reporters who traveled and
ate with the team. Here, writer
Gordon Campbell of the *Boston
Traveler* joins Hall of Famer
Warren Spahn and pitcher Walt
Lanfranconi on the train headed
for spring training. (G. Sullivan.)

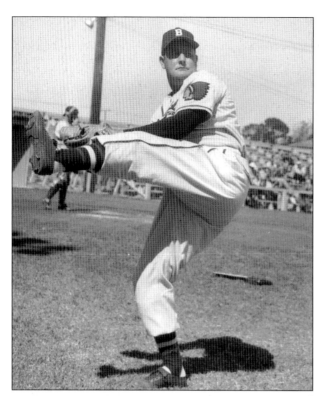

MORT COOPER, C. 1947. Former National League MVP Mort Cooper arrived in Boston in 1945 in a trade from the Cardinals in the aftermath of a protracted salary dispute. In two and a half seasons with the Braves, Cooper won 22 games and lost 20.

DANNY MURTAUGH, C. 1947. Long before he managed the Pittsburgh Pirates to World Championships in 1960 and 1971, Danny Murtaugh was a utility infielder for the Phillies, Braves, and Pirates. In three games for the 1947 Braves, Murtaugh batted .125. (J. Brooks.)

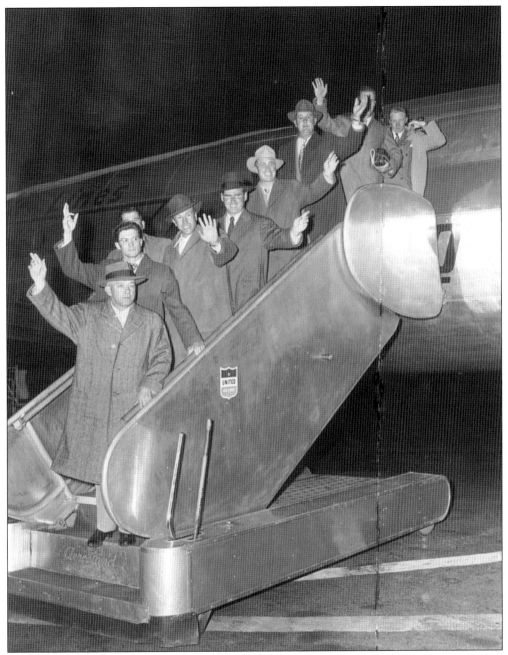

THE BRAVES ARRIVE IN BOSTON, APRIL 11, 1947. Air travel was a relatively new mode of transportation in baseball when the Braves arrived home from spring training in April 1947. Included in this photograph are, from left to right, manager Billy Southworth, first baseman Earl Torgeson, outfielder Bama Rowell, catcher Phil Masi, outfielder Tommy Holmes, outfielder Johnny Hopp, and pitcher Mort Cooper. (G. Sullivan.)

BOB ELLIOT, C. 1947. In 1947, Bob Elliot became the first third baseman in history to win the Baseball Writers of America Most Valuable Player award for the National League. The man known as "Mr. Team" enjoyed a superb season while leading the Braves to a surprising third-place finish. He batted .317 with 22 home runs and 113 RBIs. (J. Brooks.)

OUTFIELDER DANNY LITWHILER CELEBRATES THE BIRTH OF HIS DAUGHTER, APRIL 29, 1947. Danny Litwhiler, center, passes out cigars to teammates Tommy Holmes, left, and Hank Camelli in celebration of the birth of his daughter. Litwhiler, who later achieved fame as baseball coach of the Michigan State Spartans, played in 183 games for the Braves over three seasons and batted .277. (G. Sullivan.)

JOHNNY HOPP, C. 1947. Outfielder and first baseman Johnny Hopp was one of several former Cardinal stars obtained by manager Billy Southworth. In two seasons with the Braves, Hopp batted .296 and was named to the 1946 National League All-Star team. (J. Brooks.)

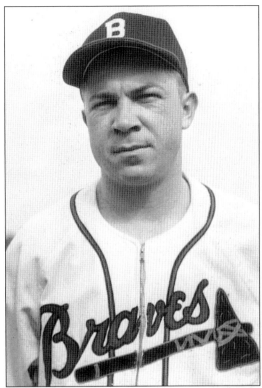

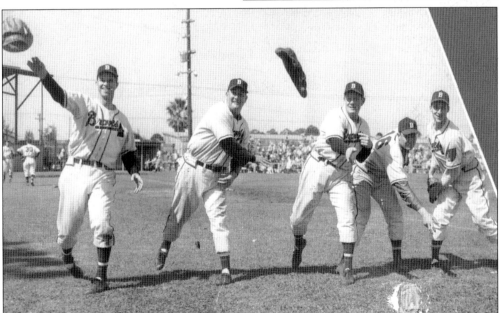

THE BRAVES "BIG FIVE" PITCHING STAFF, C. 1947. Cavorting for photographers during spring training are, from left to right, Johnny Sain, Mort Cooper, Red Barrett, Ed Wright, and Warren Spahn. Spahn enjoyed a breakthrough season with a 21-10 won-lost record. Sain matched him with 21 victories against 12 defeats for the third-place Braves. Barrett won 11 games when not moonlighting as a nightclub singer at Boston's Show Bar. (G. Sullivan.)

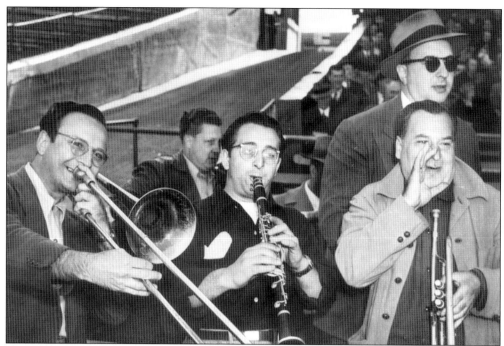

THE BRAVES TROUBADOURS AT BRAVES FIELD. The Brooklyn Dodgers had their Sym-Phony and the Braves had their Troubadours, a trio that played at Braves Field and serenaded fans with popular tunes chosen for their connection to individual players and the game at hand. The Troubadours, shown here at Braves Field in 1948, included, from left to right, Sparky Tomasetti on trombone, Sid Barbato on clarinet, and Hymie Brenner on trumpet.

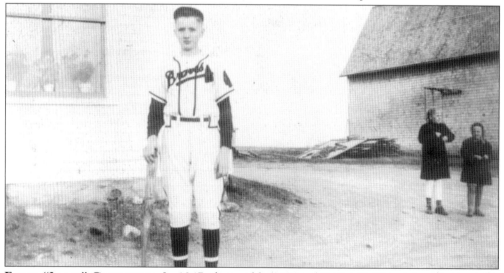

EINAR "JIMMY" GUSTAFSON. In 1947, the world-renowned Jimmy Fund was launched on the Ralph Edwards radio program. The program featured members of the Boston Braves visiting a cancer-stricken young fan who had been given a television to watch the Braves while confined in a Boston hospital. That young fan was Maine native Einar Gustafson, shown here at his family's potato farm in Maine. He is wearing a Braves uniform and holding a bat, which had been used in a Braves game, from Earl Torgeson. (Jimmy Fund.)

Eight

SPAHN AND SAIN, PRAY FOR RAIN, 1948

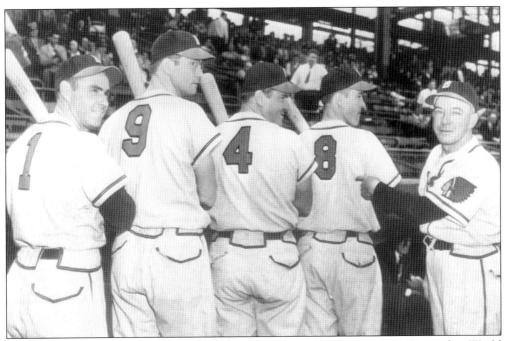

MANAGER BILLY SOUTHWORTH AND HIS "BOYS OF '48." On the eve of the Braves first World Series in 34 years, manager Billy Southworth, extreme right, spells out the numerals of his pennant-winning season with the help of, from left to right, Tommy Holmes, Earl Torgeson, Jeff Heath, and Connie Ryan. Within days of the taking of this photograph, Heath would break his leg at Ebbets Field and miss the World Series against his former teammates, the Cleveland Indians. (G. Sullivan.)

WARREN SPAHN AND JOHNNY SAIN, C. 1948. The rallying cry of the 1948 Braves Champions was "Spahn, Sain, and Pray for Rain." The lefty-righty combo combined for 39 victories and helped lead the Braves to their first pennant in 34 seasons. (SMNE.)

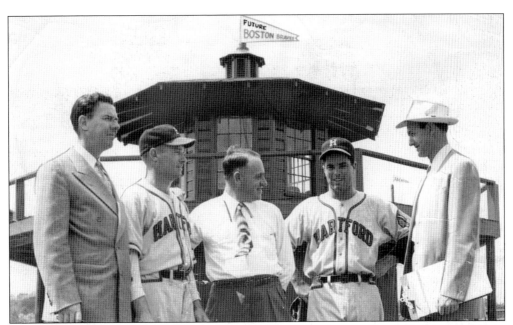

SPRING TRAINING, 1948. Braves general manager John Quinn, Hartford prospect Brooks McDowell, Braves president Lou Perini, Hartford pitcher John Fetzer, and Braves farm director Harry Jenkins pose at spring training in 1948. Quinn is shown at the Braves extensive Minor League complex. He was the second generation of a longtime baseball clan; his father had once served as chief executive of the Red Sox and his sons Robert and John would later serve as executives in both Major League baseball and the National Hockey League. (G. Sullivan.)

BATBOYS TOM FERGUSON, FRANK MCNULTY, AND CHARLES CHRONOPOULOS, C. 1948. In later years, each of the three Braves batboys pursued interesting careers in and out of baseball. Chronopoulos played Minor League baseball before entering law enforcement, where he became chief of police in Tyngsborough. Ferguson served as traveling secretary of the Milwaukee Brewers as a scout for the Phillies. McNulty served as president of *Parade* magazine for many years. (SMNE.)

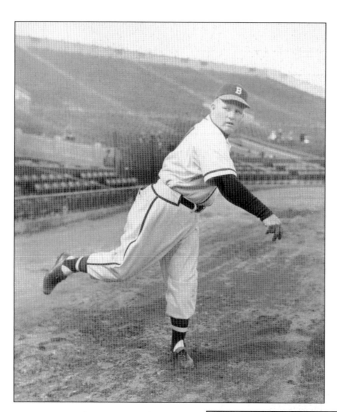

BOB HOUGE, C. 1948. Stocky right-hander Bobby Hogue was a bullpen mainstay for the champion Braves' winning of eight games in relief while losing only two. In four seasons with the Braves, Hogue had a won-lost record of 13-9. (J. Brooks.)

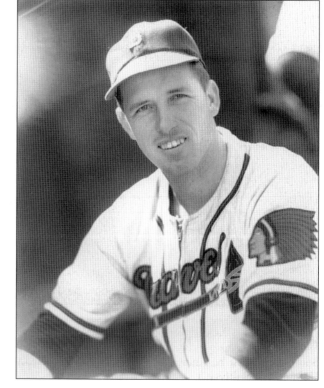

BILL VOISELLE, C. 1948. Bill Voiselle enjoyed the unique distinction of wearing the name of his hometown on his jersey. The resident of Ninety Six, South Carolina, won 13 games for the pennant, winning Braves as the third highest ranking starter after Johnny Sain and Warren Spahn. (J. Brooks.)

BILLY SOUTHWORTH, C. 1948.
Former Braves center fielder Billy Southworth returned to Boston to manage the Braves in 1946. In five seasons as manager of the St. Louis Cardinals, Southworth led his team to three consecutive World Series appearances from 1942 to 1944. He won in 1942 and 1944. He is one of a select handful of managers to have led two different teams to the World Series. (J. Brooks.)

THE 1948 BRAVES CELEBRATE GARDNER, MASSACHUSETTS DAY AT BRAVES FIELD. In the middle of a heated pennant race, the Braves find time to indulge in an opportunity for a silly photograph taken at Braves Field. They are, from left to right, manager Billy Southworth, first baseman Earl Torgeson, third baseman Bob Elliot, and right fielder Tommy Holmes. (G. Sullivan.)

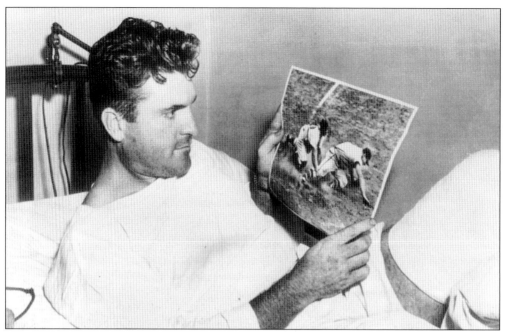

OUTFIELDER JEFF HEATH, SEPTEMBER 29, 1948. Heath recovers from his season-ending injury at Swedish Hospital in New York after leaving Ebbets Field in an ambulance just a day earlier. From his hospital bed he is viewing a photograph of the injury-causing collision with Dodger catcher Roy Campanella. (G. Altison.)

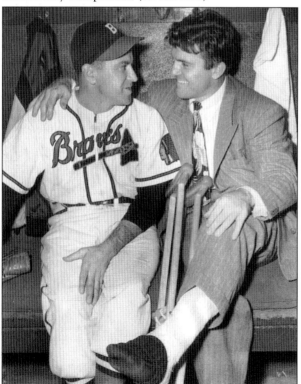

NELSON POTTER AND JEFF HEATH AT BRAVES FIELD, OCTOBER 5, 1948. Pitcher Nelson Potter shares a laugh with injured teammate Jeff Heath at Braves Field prior to the start of the 1948 World Series. The Braves sorely missed the powerful bat of Heath, who batted .319 with 20 home runs and 76 RBIs while playing a solid left field. (G. Sullivan.)

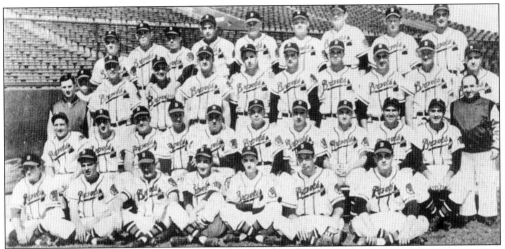

THE 1948 NATIONAL LEAGUE CHAMPION BOSTON BRAVES. Shown from left to right are the following: (first row) Paul Burris, Bob Sturgeon, Clint Conaster, Charles Chronopolous (bat boy), Tom Ferguson (ball boy), Vernon Bickford, and John Antonelli; (second row) Phil Masi, Warren Spahn, Jeff Heath, Bob Keely (coach), Fred Fitzsimmons (coach), Billy Southworth (manager), John Cooney (coach), Al Dark, Tommy Holmes, Sibby Sisti, and George Young (property man); (third row) Charles Lacks (trainer), Si Johnson, Ray Sanders, Al Lyons, Frank McCormick, Bill Voiselle, Earl Torgeson, Johnny Sain, Clyde Shoun, Bob Elliott, and Nelson Potter; (fourth row) Connie Ryan, Bill Salkeld, Eddie Stanky, Mike McCormick, Ernie White, Bob Hogue, Charles Barrett, Glenn Elliott, and John Beazley.

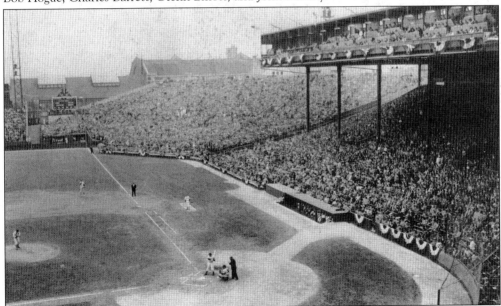

BRAVES FIELD, 1948 WORLD SERIES. Until 1948, Braves Field served as home to two World Series, both triumphant Red Sox efforts in 1915 and 1916. In 1948, the park hosted its first and only World Series for the home team. The Indians captured games two and six at the wind-swept park as part of their six-game victory. Note that the right field grandstand from the auxiliary scoreboard to the split in the middle of the still exists as part of Nickerson Field at Boston University. (G. Altison.)

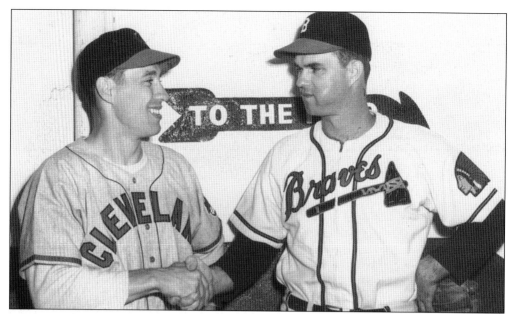

BOB FELLER AND JOHNNY SAIN, GAME ONE, 1948 WORLD SERIES. Although Cleveland ace Bob Feller won 19 games and led the American League in strikeouts in 1948, he lost twice in the 1948 World Series and never won a World Series game in his fabulous Hall of Fame career. In 1948, Sain led the National League in wins with 24, complete games with 28, and innings pitched with 315. He outdueled Feller by a score of 1-0 in game one and lost game four by a score of 2-1 to Indians dark horse Steve Gromek. (G. Altison.)

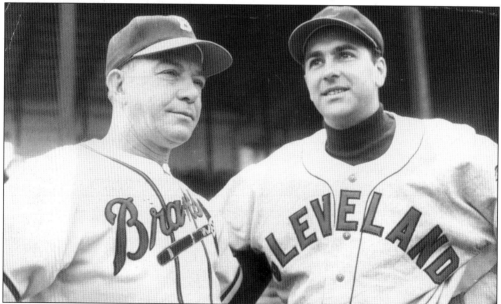

BILLY SOUTHWORTH AND LOU BOUDREAU, 1948 WORLD SERIES. Indians player-manager Lou Boudreau greets Braves manager Billy Southworth prior to the first World Series game ever played by the Braves at Braves Field. Boudreau had just prevented Boston's only streetcar World Series by leading his team to victory over the Red Sox in a one-game championship playoff game at Fenway Park with a four-for-four performance capped by two home runs. (Author's collection.)

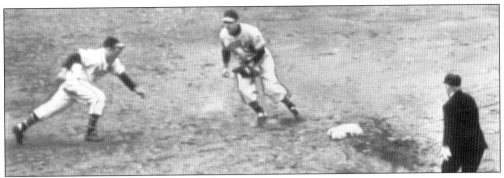

THE PHANTOM PICKOFF, GAME ONE, 1948 WORLD SERIES. In the most controversial play of the 1948 World Series, Braves catcher Phil Masi was sent in to pinch run for catcher Bill Salkeld, who drew a leadoff walk from Bob Feller in the bottom of a scoreless eighth inning in the first game of the 1948 World Series at Braves Field. Masi advanced to second on a sacrifice bunt by Mike McCormick and watched as the Indians walked the Braves eighth batter, Eddie Stanky, to set up a force play. After Sibby Sisti pinch ran for Stanky and Johnny Sain entered the batter's box, Indian pitcher Bob Feller wheeled and threw to shortstop Lou Boudreau to attempt to pick off Masi. Umpire Bill Stewart, a Boston native and former Stanley Cup–winning coach with the Chicago Blackhawks, called Masi safe. Braves Field let out a collective sigh of relief as Boudreau protested the call. After Sain lined-out, right fielder Tommy Holmes lined a single to the left to score Masi with the game's only run. This four-frame sequence shows Stewart had a full view of the play. (G. Altison.)

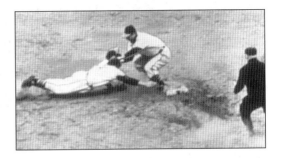

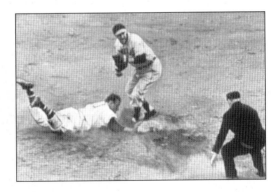

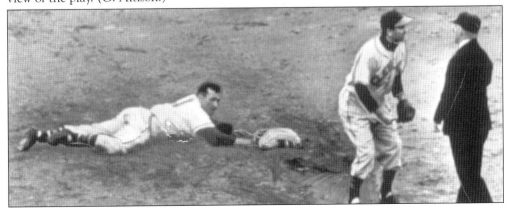

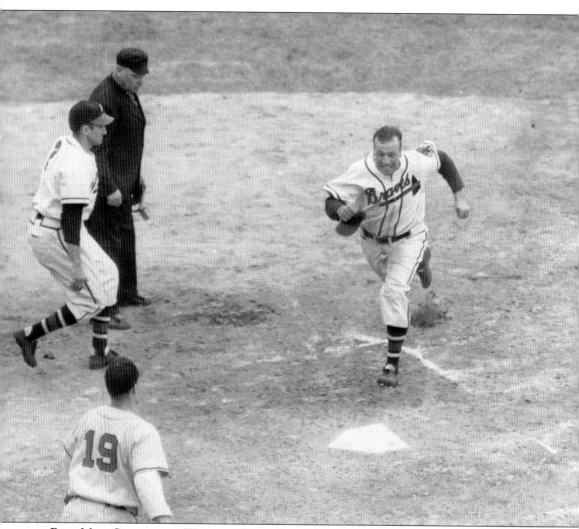

PHIL MASI SCORES THE WINNING RUN, GAME ONE, 1948 WORLD SERIES. Just before his death, Masi admitted that he was most likely out on the controversial pick-off play. However, despite their luck on that crucial play, the Braves still could not match the Indians overall depth and ended up losing the hard-fought series in six games.

TOMMY HOLMES AND JOHNNY SAIN, GAME ONE, 1948 WORLD SERIES. Ace right-hander Johnny Sain is shown in the Braves clubhouse following his masterful performance in the first game of the 1948 World Series. In pitching the first 1-0 shutout in a World Series since Jim Bagby in 1920, Sain scattered four singles and struck out six Indians. Holmes made one of the Braves' two hits off Bob Feller count as he drove in the game's only run with an eighth-inning single. (G. Altison.)

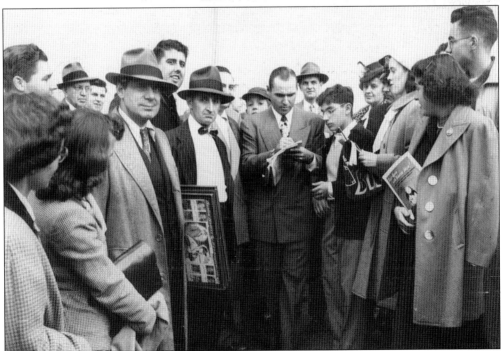

TOMMY HOLMES AT THE 1948 WORLD SERIES. Tommy Holmes is besieged by fans following the first game of the 1948 World Series at Braves Field. Holmes was one of the Braves' heroes because he had made the hit that scored Phil Masi with the lone run. This supported Johnny Sain's 1-0 shutout of the Indians. (SMNE.)

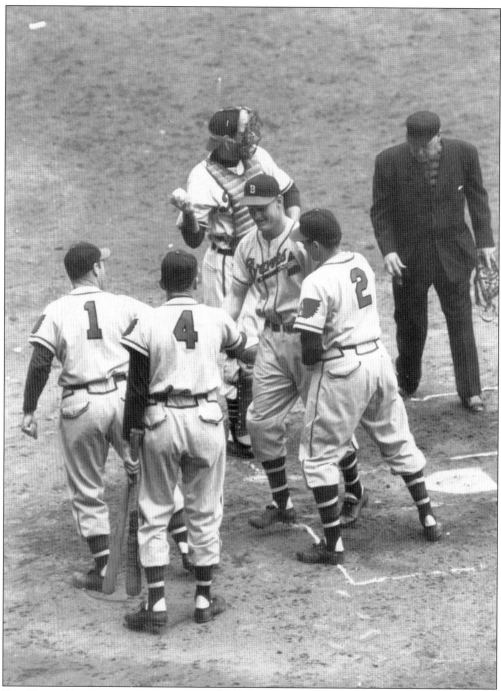

BOB ELLIOT'S HOME RUNS IN GAME FIVE, 1948 WORLD SERIES. Bob Elliot insured a return to Braves Field with a three-run first-inning home run in game five against Indians ace Bob Feller. Among the Braves greeting Elliot are Tommy Holmes (No. 1), Alvin Dark (No. 2), and Marv Rickert (No. 4). The Braves won the game by a score of 11-5 in a game that saw Elliot hit two home runs. (G. Altison.)

WARREN SPAHN, C. 1948. Long before achieving stardom, left-hander Warren Spahn endured a Minor League demotion by Casey Stengel and service as a combat veteran of such World War II campaigns as the Battle of the Bulge. Upon his return to the Braves rotation in 1946, he won his first Major League game in an eight-victory season, soon followed by a 21-10 season in 1947 and a 15-12 season in 1948. He is credited with helping lead the Braves to the World Series in 1948. (SMNE.)

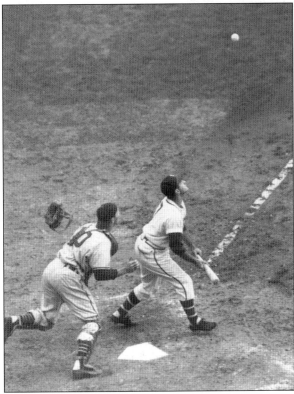

SIBBY SISTI DNDS THE 1948 WORLD SERIES. With one on and one out in the ninth inning of a one-run game, Sibby Sisti popped up on a sacrifice bunt attempt. When Connie Ryan was doubled off first base, the Cleveland Indians won their first World Series in 28 years. (SMNE.)

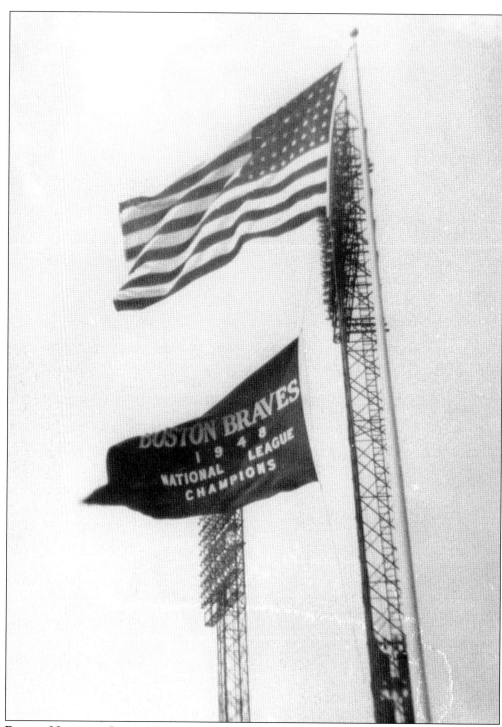

BRAVES NATIONAL LEAGUE PENNANT, APRIL 1949. It had been 34 years since a championship banner had flown over Braves Field when the National League pennant was unfurled in April 1949. Little did fans realize that their team would only play in Boston for four more seasons before embarking for the home of their Triple A affiliate in Milwaukee. (G. Altison.)

Nine

THE LONG GOODBYE, 1949–1953

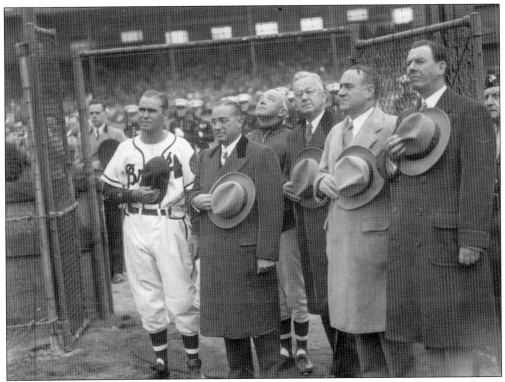

THE 1948 NATIONAL LEAGUE PENNANT, OPENING DAY 1949. Braves players and officials rose the pennant at the opening of the 1949 season. Shown from left to right are right fielder Tommy Holmes, Braves part-owner Guido Rugo, manager Billy Southworth, part-owner Joe Maney, part-owner Louis Perini, and general manager John Quinn. (G. Sullivan.)

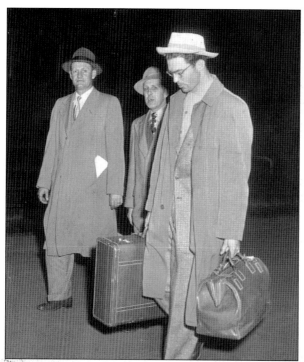

BOB ELLIOT AND EARL TORGESON ARRIVE AT SOUTH STATION, APRIL 1949. First baseman Earl Torgeson carries the luggage of injured teammate Bob Elliot as the Braves arrive home for a series game against the New York Giants in 1949. Torgeson had injured his shoulder and played only 25 games for the season. The injury bothered him for the remainder of a 14-year Major League career that saw him sock a total of 149 home runs. (G. Sullivan.)

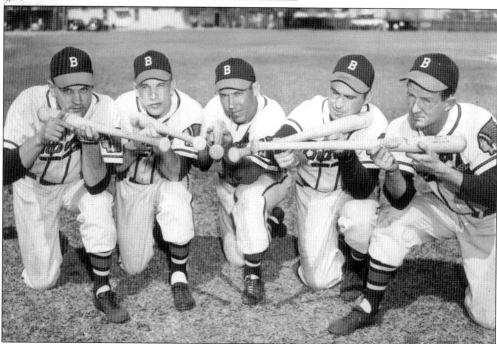

BRAVES OUTFIELDERS, MARCH 1949. Prepared to do baseball battle, the Braves prepared to defend their pennant with, from left to right, outfielders Marv Rickert, Art Moore, Pete Reiser, Tommy Holmes, and Clint Conatser. The 1949 team finished four games below .500 for a disappointing finish that helped lead to their departure from Boston just three years later. (G. Sullivan.)

WARREN SPAHN AND JOHNNY SAIN, C. 1949. In a rare candid photograph, the two Braves pitching aces relax before boarding a train. Both men meant everything to the Braves, as they were the best righty-lefty starting pitching combination in baseball. Sain won 104 games and Spahn 122 in seven complete seasons in Boston. (G. Sullivan.)

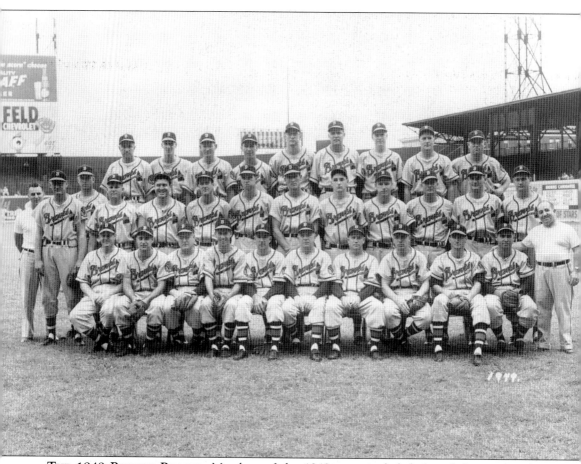

THE 1949 BOSTON BRAVES. Members of the 1949 team included, from left to right, the following: (front row) Red Barrett, Sibby Sisti, Si Johnson, Bob Keely, Billy Southworth, Jimmy Brown, Eddie Stanky, Alvin Dark, Tommy Holmes, and Shorty Young; (middle row) Dr. Charles Lacks, Bob Elliot, Bill Voiselle, Bob Houge, Jeff heath, Connie Ryan, Johnny Sain, Robert Hall, John Antonelli, Ed Sauer, ? Kivingston, Marv Rickert, and Jim Russell; (back row) Nelson Potter, Warren Spahn, G. Elliot, Pete Reiser, Earl Torgeson, Ray Sanders, Del Crandell, Elbie Fletcher, and Bill Salkeld. (Author's collection.)

JEFF HEATH AND PETE REISER, C. 1949. Slugging outfielder Jeff Heath greets his new teammate Pete Reiser, who had arrived in Boston after being traded by the Dodgers for outfielder Mike McCormick. Both men had careers marked by devastating injuries. Reiser played center field the way Ty Cobb ran the bases and as a result suffered several catastrophic collisions with outfield walls. Heath broke his leg in a game against the Giants on the eve of the 1948 World Series and missed the chance to battle against his former Cleveland teammates.

VERN BICKFORD, WARREN SPAHN, AND JOHNNY SAIN, C. 1950. The Braves nearly enjoyed the distinction of having three starters with 20 victories or more in 1950, when Warren Spahn and Johnny Sain won 21 and 20 games, respectively. Vern Bickford finished the season with a won-lost record of 19-14, which included the seventh no-hitter in franchise history, a 7-0 shutout of the Dodgers on August 11, 1950. (G. Sullivan.)

WELCOME TO BOSTON. Braves manager Billy Southworth, left, greets the trio of former New York Giants for whom he had traded Alvin Dark and Eddie Stanky. They are, from left to right, outfielder Willard Marshall, outfielder/third baseman Sid Gordon, and shortstop Buddy Kerr. The trade is still discussed by Braves diehards as one of the worst in team history because Dark and Stanky soon helped lead the Giants to two pennants (1951 and 1954) in four seasons. (G. Sullivan.)

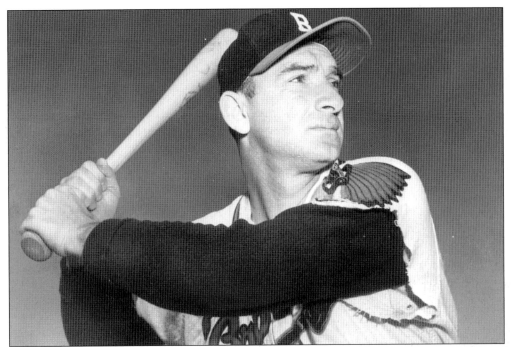

SID GORDON, C. 1950. Outfielder/third baseman Sid Gordon arrived in Boston as the result of the disastrous trade that sent shortstop Dark and second baseman Stanky to the Giants for four players, one of whom was slugger Sid Gordon. In 1950, Gordon tied a Major League record by slugging four grand slams for the season. (J. Brooks.)

BOB ELLIOT AND GENE MAUCH AT BRAVES FIELD, APRIL 1950. Future Major League manager Gene Mauch joins veteran Bob Elliot for a look through their mail as they prepare for a city series game versus the Red Sox prior to the start of the 1950 season. Mauch served as a utility infielder for the Braves in 1950 and 1951, batting just .213 over 67 games. (G. Sullivan.)

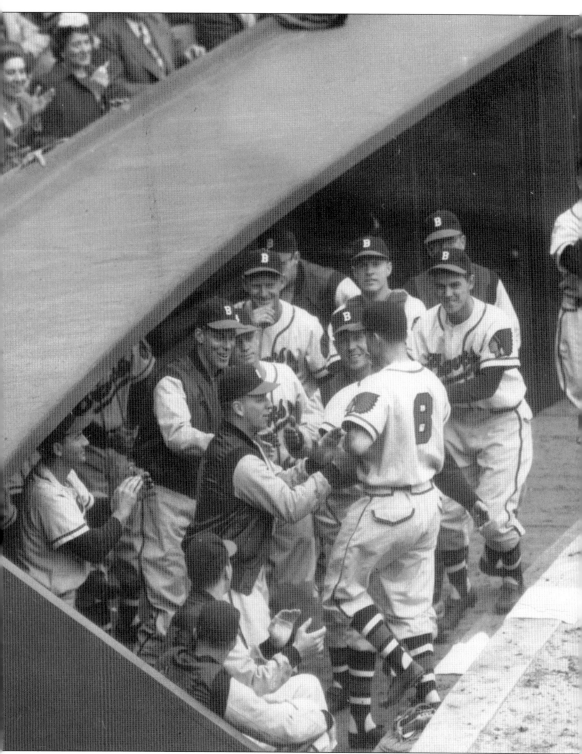

WARREN SPAHN, OPENING DAY, 1950. Warren Spahn, right, strides toward the Braves dugout at the Polo Grounds on Opening Day 1950. The Braves supported him with an 11-4 victory

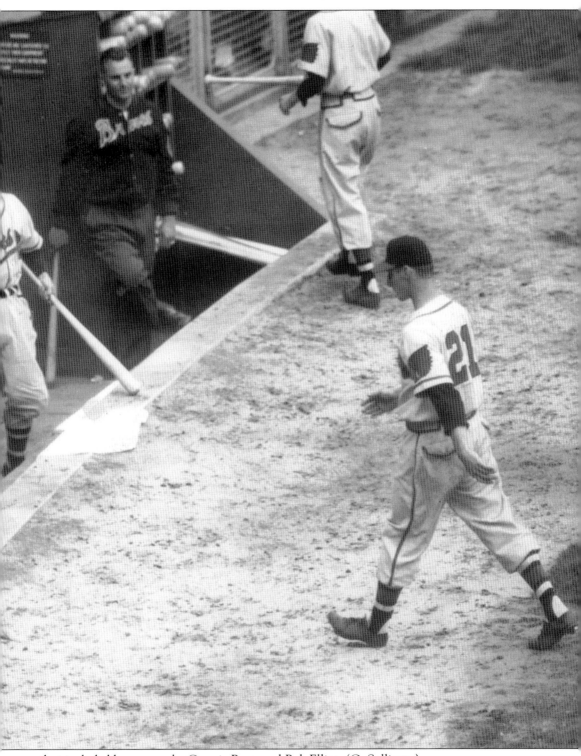

that included home runs by Connie Ryan and Bob Elliot. (G. Sullivan.)

THE 1950 BRAVES SCORECARD. The Braves, under the direction of publicist and future Boston and New England Patriots owner Billy Sullivan, were among the first Major League teams to offer full-color scorecards. The team also produced the first color highlight film in Major League baseball.

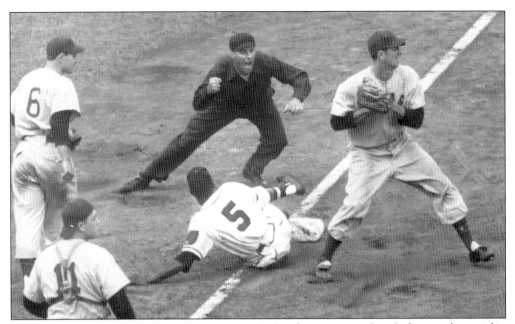

SAM JETHROE TAGGED OUT AT THIRD, C. 1950. Rookie sensation Sam Jethroe is shown after being tagged out by Cub shortstop Roy Smalley at third base following a ground out by Bob Elliot. Making the call at Braves Field is umpire Augie Donatelli. The speedy Jethroe was the first professional, team sport, African American athlete in Boston. Not only did he home run in his first game but also led the league with 35 stolen bases. (G. Altison.)

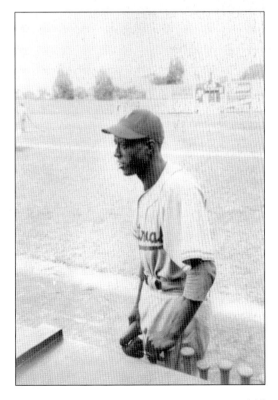

SAM JETHROE AS A MEMBER OF THE MONTREAL ROYALS. The Boston Braves obtained outfielder Sam Jethroe prior to spring training in 1950. During the previous season, Jethroe set an International League season stolen base record with 89 as a member of the Dodgers Triple A affiliate in Montreal. The Dodgers sold him to the Braves for $100,000. (G. Altison.)

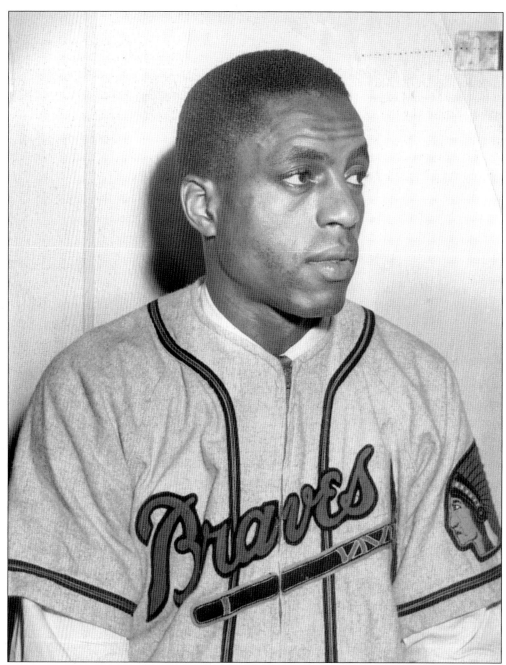

SAM JETHROE, C. 1950. After having been rejected by the Red Sox in the now-infamous April 1945 tryout conducted for them, Jackie Robinson, Larry Woodall, and outfielder Sam Jethroe returned to Boston with a vengeance in 1950. Despite having spent the better part of his career with the Cleveland Buckeyes of the Negro League, Jethroe captured Rookie of the Year honors at age 28. In his three seasons in Boston, Jethroe batted .261 with 49 home runs and 98 stolen bases. (G. Altison.)

NORMIE ROY, C. 1950.
Waltham High School
standout Normie Roy reached
the Braves in 1950 after only
three seasons in the minors.
In his only Major League
season, Roy pitched in 19
games, winning four, losing
three, and compiling an ERA
of 5.13. Arm troubles soon
forced his early retirement
from baseball. (G. Altison.)

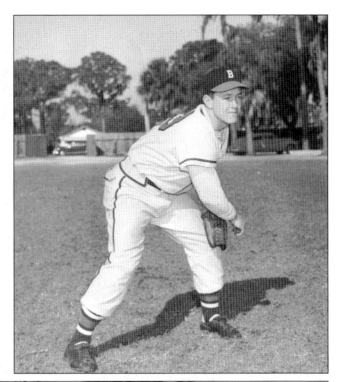

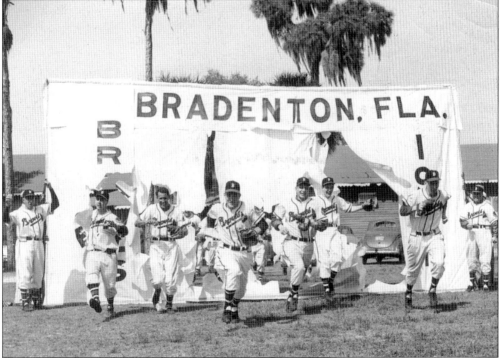

THE BOSTON BRAVES OPEN SPRING TRAINING, MARCH 1951. In the time-honored tradition of
taking corny photographs, the Braves played to both the still photographers and newsreel crews
as they opened spring training by charging though this elaborate paper sign. (G. Sullivan.)

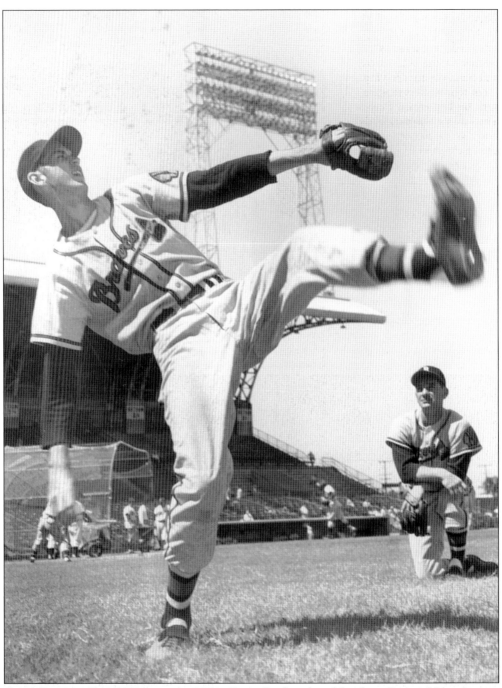

GENE CONLEY, SPRING TRAINING, 1951. Gene Conley played for three Boston Major League franchises. He pitched for both the Braves and Red Sox and served as Bill Russell's backup on the Boston Celtics. The six-foot, eight-inch right-hander achieved one of the greatest doubles in sports. He also won three World Championships with the Celtics and one with the Milwaukee Braves, in 1957. In four games with the Boston Braves in 1952, Conley was 0-3 with a 7.82 ERA. (J. Brooks.)

DICK DONOVAN, C. 1951. Dick Donovan of Quincy achieved great fame as a pitcher for the White Sox and Senators after having spent four winless seasons with his hometown Braves. The lanky right-hander did not win the first of his 122 career victories until he turned 28.

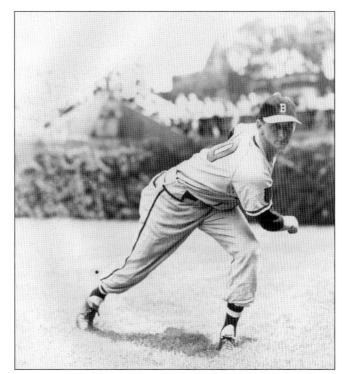

DEL CRANDELL, C. 1951. Catcher Del Crandell joined the Braves at age 19 in 1949 and soon split the team's catching duties with Bill Salkeld. After another year of backup service to Walker Cooper, Crandell served in the military for two seasons before returning to Boston. After the Braves moved to Milwaukee, Crandell not only became a regular but was named captain of a club that included such stars as Aaron, Matthews, Spahn, Adcock, and Burdette.

THE 1951 BRAVES SCORECARD. In 1951, the Braves experienced the first of two cataclysmic drops in attendance. The club drew a total home attendance of only 487,475, down from an attendance of 944,391 the previous season. The following season, the team drew only 281,278 in their final season in Boston.

BRAVES LOOK-ALIKES EARL TORGESON AND MURRAY WALL, C. 1951. Many fans did double takes when pitcher Murray Wall joined the Braves in 1950 because he was a dead ringer for veteran first baseman Earl Torgeson. The lanky right-hander pitched just one game for the Braves, a four-inning stint that produced six hits and a 9.00 ERA. (G. Sullivan.)

BRAVES SOUTHPAWS LIMBER UP, SPRING TRAINING, 1951. Lefties in this photograph are, from left to right, Bob Chipman, Warren Spahn, Jim Pope, Dick Kelly, and Chester Nichols. Only Spahn, Nichols, and Chipman made it to Braves Field in 1951. Spahn enjoyed a 22-win season and led the National League with 26 complete games and 164 strikeouts. Nichols turned out to be the pitching find-of-the-season as he compiled a league-leading 2.88 ERA with an 11-8 won-lost record compiled while splitting starting and relieving duties. Chipman was 4-3 as a relief pitcher. (G. Sullivan.)

CHET NICHOLS, SEPTEMBER 27, 1951.
Rookie pitcher Chet Nichols stopped the
Brooklyn Dodgers in the heat of one of the
great pennant races when he led the Braves
to a 4-3 victory at Braves Field. His six-hit
win over Preacher Roe cut the Dodgers lead
over the Giants to just half a game. Within
the week, the Giants and Dodgers played
a three-game playoff capped by Bobby
Thomson's "shot heard round the
world." (J. Brooks.)

BOSTON GREATS CELEBRATE NATIONAL LEAGUE DIAMOND JUBILEE. Three of Boston's
greatest baseball stars gathered on June 2, 1951, to celebrate the National League's 75th
anniversary. From left to right they are Boston Beaneater outfielder Hugh Duffy, Miracle Brave
shortstop Rabbit Maranville, and former Red Sox great and Boston Braves traveling secretary
Duffy Lewis. (G. Sullivan.)

EDDIE MATTHEWS, C. 1952. Not only was Eddie Matthews the 1952 National League Rookie of the Year, he was also the only Brave to play in Boston, Milwaukee, and Atlanta. His matinee idol good looks and powerful swing made him a fan favorite for the team's glory days in Milwaukee in the late 1950s.

JACK DITTMAR, GEORGE CROWE, AND DON LIDDLE IN PUERTO RICO, C. 1952. In the days when winter baseball was essential to the development of Major Leaguers, the Braves sent second baseman Jack Dittmar, first baseman George Crowe, and pitcher Don Liddle to the Puerto Rican League's Senadores for seasoning. Both Crowe and Dittmar saw moderate service with the 1952 Braves while Liddle was called up to the newly relocated Milwaukee Braves the following season. (G. Sullivan.)

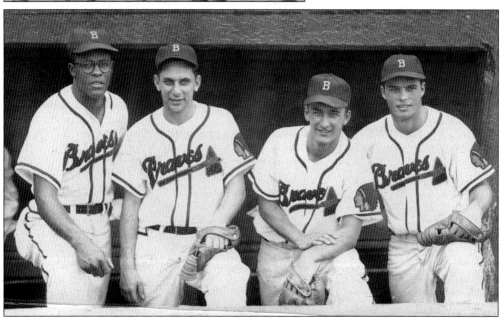

THE 1952 BOSTON BRAVES ALL-ROOKIE INFIELD. Members of the 1952 infield are, from left to right, George Crowe, first base; Jack Dittmar, second base; Johnny Logan, shortstop; and Eddie Matthews, third base. The nucleus of the great Milwaukee Brave teams of the 1950s started gelling with the last Boston Brave team in 1952. Matthews captured Rookie of the Year honors, and Logan batted .283 in his first full Major League season. Dittmer and Crowe enjoyed more limited success but made the move to Milwaukee as starters. (G. Sullivan.)

EDDIE MATTHEWS AND EBBA ST. CLAIRE AT THE HOTEL KENMORE. Rookie third baseman Eddie Matthews was expected to fill the large shoes of Bob Elliot for the 1952 Braves. The 20-year-old possessed movie star looks and soon proved to be a budding star with 25 home runs and the National League Rookie of the Year Award. Ebba St. Claire served as the Braves' catcher during Del Crandell's military hitch and played three of his four Major League seasons for the Braves. (G. Sullivan.)

LOUIS PERINI, C. 1949. Louis Perini, with fellow owners Guido Rugo and Joe Maney, helped rebuild the Braves franchise in Boston. Despite his efforts, Perini will forever be remembered as the man who moved the team to Milwaukee. During his tenure in Boston, Perini helped start the Jimmy Fund of the Dana Farber Cancer Institute in 1947. It is this legacy that is perhaps his most significant. The Jimmy Fund has treated countless patients and is in the forefront of cutting-edge developments to cure the dreaded disease. (SMNE.)

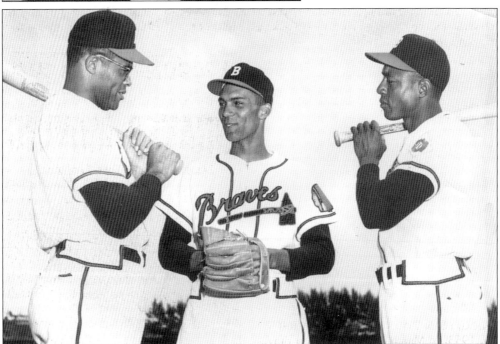

GEORGE CROWE, BILL BRUTON, AND SAM JETHROE, C. 1953. Long before the crosstown Red Sox had broken the color line, the 1952 Braves featured a lineup that included such African Americans as 1950 National League Rookie of the Year Sam Jethroe and first baseman George Crowe. Outfielders Bill Bruton and Hank Aaron had yet to make the majors by the time the Braves' move to Milwaukee was announced on March 13, 1953. (G. Altison.)

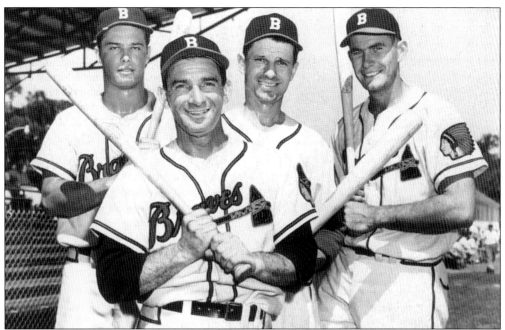

SPRING TRAINING, 1953. This rare photograph features, from left to right, Eddie Matthews, Sid Gordon, Andy Pafko, and Joe Adcock. Note that Joe Adcock is in a Boston Braves uniform in his first spring training after being traded to the Braves by the Reds. Before camp broke, the franchise moved to Milwaukee, where Adcock, Matthews, and Pafko helped lead the team to pennants in 1957 and 1958.

CHICAGO SUN TIMES **HEADLINE, MARCH 16, 1953.** In March 1953, the Boston Braves became the first Major League franchise to relocate since the Baltimore franchise of the American league moved to New York and became the Highlanders (Yankees) in 1903. (Author's collection.)

130 SUN-TIMES EXTRA
CHICAGO DAILY

CHICAGO, WEDNESDAY, MARCH 18, 1953

BRAVES MOVING

Boston Ball Team Goes To Milwaukee

Final game at Braves' Field

The first major league relocation since 1903 came today when the Boston Braves were transferred to Milwaukee. Their new home will be the $5,000,000 Milwaukee County Stadium, with a seating capacity of 48,000.

©T.C.G. PTD. IN U.S.A.

See Scoop 131 — WRONG WAY CORRIGAN

BRAVES FIELD DEMOLITION, C. 1959. After 44 years, Braves Field was mostly demolished by Boston University in 1959 to make way for dormitories and a new outdoor athletic complex. Only the front offices and right field grandstand survived the demolition and remained in place at the beginning of the 21st century. (Boston University.)